BASEBALL
IN
CHATTANOOGA

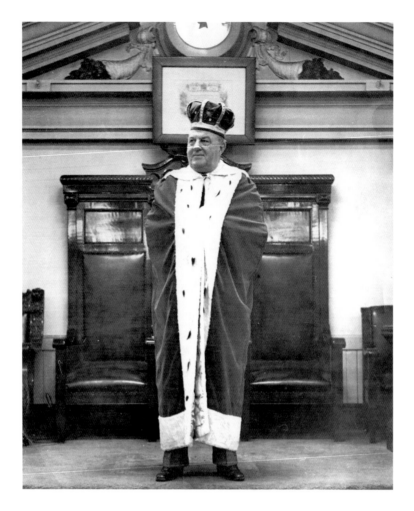

GOOD KING JOE. When crowned the minor league "King of Baseball," an annual honor bestowed during the winter meetings, Chattanooga Lookouts president Joe Engel commissioned this modest portrait and had dozens of prints made. He then sent them to players, writers, other owners, and especially umpires. (Courtesy author.)

Front cover: A TYPICAL LOOKOUT. Catcher Johnny Marr was a midseason callup for the 1957 Chattanooga club, helping them earn a berth in the playoffs. (Courtesy author.)

Back cover: NEW CENTURY, NEW HOME. After 70 seasons at Engel Stadium, the Chattanooga Lookouts moved to their new home, BellSouth Park. (Courtesy author.)

BASEBALL
IN
CHATTANOOGA

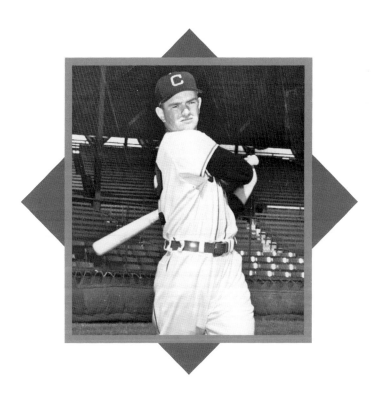

David Jenkins

ARCADIA
PUBLISHING

Published by Arcadia Publishing
Charleston, South Carolina

Printed in the United States of America

Library of Congress Catalog Card Number: 2005932374

For all general information contact Arcadia Publishing at:
Telephone 843-853-2070
Fax 843-853-0044
E-mail sales@arcadiapublishing.com
For customer service and orders:
Toll-Free 1-888-313-2665

Visit us on the Internet at www.arcadiapublishing.com

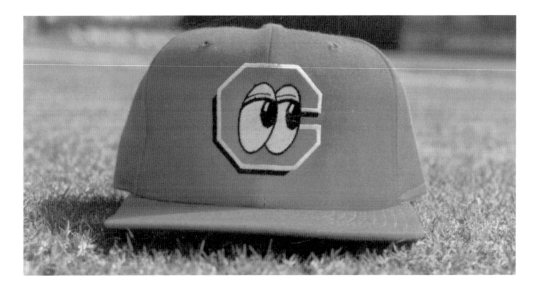

SEEING DOLLAR SIGNS. The eyes have it. In this case, "it" is major moneymaking potential. Lookouts general manager Bill Davidson and owner Rick Holtzman, polishing an idea first put forward by former general manager Bill Lee, had the distinctive logo designed in 1990 just as minor league marketing was becoming a national phenomenon. A decade and a half later, it remains one of the top sellers in the minors. (Courtesy Lookouts.)

CONTENTS

ACKNOWLEDGMENTS

The author wishes to thank the people who made baseball in Chattanooga a living entity for the past 110 years. Special thanks go to those who lent their voices to this narrative: Frank Burke, who could and should eclipse Joe Engel himself as the towering figure in this city's baseball history; Cal Ermer, whose stories of "those days" are cherished by all who hear them; Larry Ward, who has kept his enthusiasm for baseball in his voice for the past 18 years; and Stump Martin, whose love of amateur baseball rivals Engel's love of the professional game. Personal thanks go Ron Bush and Maggie Bullwinkel, proving two are better than one; my great friend Kilah, who has been an example of beating back adversity with positive thoughts and deeds; Roy Exum, who had the good sense and vision to hire a 15-year-old kid to work in his sports department; and to all those establishments that continue to tolerate me sitting for three hours reading newspapers and drinking iced tea. And thanks to Abner Doubleday/Alexander Cartwright/the Native Americans (choose one), whoever really thought of it first.

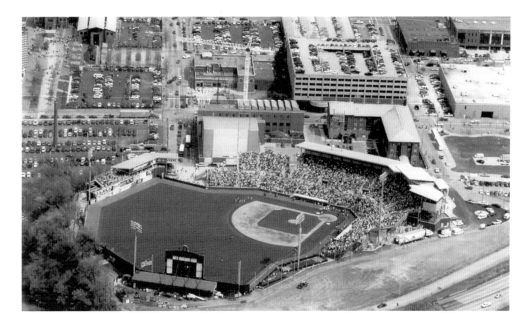

THE FINISHED PRODUCT. The transformation complete, Hawk Hill became BellSouth Park in time for the 2000 season. A full house gathered on April 1 for the dedication, an exhibition game between the Cincinnati Reds and Baltimore Orioles. The site previously held high school football and baseball fields for defunct Kirkman Technical High School, which stood where the L-shaped hotel now stands. (Courtesy Lookouts.)

INTRODUCTION

Baseball has died in Chattanooga so many times that it's a miracle that it lives at all. Instead it has never been healthier thanks to ownership that combines a youthful love of the game with a serious bankroll to make dreams real. Over the years, you can see Chattanooga's saviors of our pastime: O. B. Andrews, who could see the interest in amateur baseball and believed it would carry over; Joe Engel himself, who promised a stadium and delivered it in record time; Woody Reid, who saw beauty and possibilities where many saw an eyesore ready for the wrecking ball; Rick Holtzman, who wound up being universally hated but who got Engel Stadium restored long enough for BellSouth Park to become a reality. Then there's Frank and Daniel Burke, whose vision for Hawk Hill, a run-down high-school football stadium, provided the finishing touch to a 20-year-old civic dream called the Golden Gateway.

Through the years, the historic high points of Chattanooga baseball—Jackie Mitchell, Joe Engel's promotions, Cecil Travis, Harmon Killebrew, Joe Charboneau, and so on—have become part of the game's folklore. But for every piece of trivia that lives, a dozen wonderful stories worth telling are lost forever. I have no way of knowing how many I've missed, never to be retold, but I have done my level best to bring out some of the wondrous moments that you might like to know. It is up to you to decide whether or not the Lookouts (and all those other forms baseball has taken locally) are more alive in your eyes after reading this.

The first thing you need to know is that, without Joe Engel, there would likely be no "baseball in Chattanooga." The city had lost and regained franchises three different times in early, halting attempts to field a professional baseball team. Engel, under the guidance of Senators owner Clark Griffith, bought the Chattanooga franchise and had Engel Stadium built on the site of the city's old ballpark, Andrews Field. It was a jewel of a park in its day and durable enough that, with renovations, was still to be used 70 years after its construction.

Engel's promotions are legend. While he loved the nickname "Barnum of Baseball," he was also called the "Baron of Baloney." Both fit. Engel Stadium's first opener (April 23, 1930) drew a crowd of 15,184. Chattanooga's Opening Day gate was even better in 1931 (17,043). Over the years, Opening Day stunts included an "elephant hunt" (complete with loincloth-clad spear carriers) that was highly criticized until it was shown to be a put-on complete with papier-mâché pachyderms. Engel appalled many by staging events like "Custer's Revenge" and a "phone call" to Adolf Hitler as comedic draws. But people came.

Engel's biggest promotion was the 1936 house giveaway. Not a gimmick, the house was specially built for the promotion, and a crowd of just under 25,000 (a single-game record) turned out for the drawing. The game also marked the beginning of night baseball at Engel Stadium. Engel's most famous deal was when he shipped shortstop Johnny Jones to Charlotte (also a Washington farm club) for a turkey—which he had prepared for the media. Engel later said, "Felix [Hayman, Charlotte club president] came out ahead on that deal. That turkey was tough."

Engel's decline was as pathetic as his glory days were giddy. The Lookouts drew fewer than 26,000 fans in their final, last-place season of 1965, and player Al Raffo (later an area educator)

later said that Engel never once visited the team in the clubhouse all season. The final day of that season, dubbed "Save the Lookouts Day," drew 355 fans. It took Woody Reid's dream and timely buy-ins by local businessmen Jim Crittenden and Harry Landreth more than a decade later to keep Engel's legacy alive, if not well.

To that end, without Frank Burke, the final chapter in Chattanooga baseball might have already been written. When Burke saved the franchise from the confrontational, debt-ridden stewardship of absentee-owner Rick Holtzman, the franchise was as likely to be moved as kept. Burke did his level play to make money playing at decaying Engel Stadium but with his father, Daniel Burke, displayed remarkable vision in getting BellSouth Park built on what was literally the most valuable vacant lot in the entire city.

Frank Burke stated:

> On a Christmas Eve, my dad was in town and we were returning from Engel Stadium to my home on Signal Mountain. My father pointed to Hawk Hill, an old high school football field next to the highway. He asked me what the city planned to do with that land, and I said I didn't know. My father asked me to drive him up the hill, as he thought it might be big enough to hold a baseball stadium. He paced off the distance from one end of the property to the other. When he returned to the car, soaked with rain, he said it would be tight but said, "I believe a stadium could fit on that property."

Burke hung onto that thought for the next three seasons as Engel Stadium became more and more costly to operate. In the summer of 1998, frustrated over the lack of interest from city and county executives to build a stadium for the team, he met with his father at his Maine home. Daniel Burke said that he thought a stadium could be built affordably if the land was either donated or leased at a low cost.

Upon his return, a message was given to then-mayor Frank Kinsey: the Lookouts would build the stadium privately but only if it were on Hawk Hill. The plan resonated with the right people and, following a season ticket drive that secured more than 1,800 seats sold for a three-year block, Burke moved forward and began the new century in a new stadium, BellSouth Park.

Trying to cram a century's worth of information into this volume was impossible. But little-known Lookouts facts have turned up throughout its research. We've learned about Elliott Bigelow, perhaps Chattanooga's first superstar, who drove in a team record 125 runs in 1931 and was dead of meningitis less than two years later. There was Ray Treadaway, who had 210 hits for the 1930 Lookouts at age 22, was out of baseball at age 25, and was dead at age 27, mortally wounded on a downtown Chattanooga street.

Little has ever been written about the Lookouts' Cuban connection, but in 1944—two years before the Dodgers signed Jackie Robinson—the Lookouts had 14 Cubans on their roster, including the Southern Association batting champion, Rene Monteagudo. Roberto Ortiz, who hit .360 in his only season in Chattanooga, was a Latin legend who is one of three former Lookouts in the Cuban Baseball Hall of Fame. His funeral in Miami drew thousands, and a pre-Castro Cuban movie was done on his life.

Thanks to the following contributors: the Chattanooga Lookouts, the Chattanooga Regional History Museum, the Baseball Hall of Fame and Museum, and avid photographers Alan Vandergriff and Tim Evearitt (of Chattanoogan.com). Many of the 1940–1950s photographs that dot this book were literally saved from the trash; heaven knows how many more could have been saved if the people in power had any sense of history.

A SECOND CHANCE

Engel Stadium, for years the jewel in the Southern Association's impressive array of ballparks, stood in disrepair in the late fall of 1975.

Professional baseball had abandoned Chattanooga a decade before. Joe Engel, the iconic figure who kept baseball alive, if not always thriving, in the city for 35 years, had died six years earlier. His will dictated that the stadium's many prizes, including photographs, trophies, and even his desk, be shipped off to the Baseball Hall of Fame in distant Cooperstown, New York. So it was a shell of a stadium that Southern League president Billy Hitchcock, Oakland Athletics farm director Syd Thrift, and prospective Chattanooga team owners Woody and Mark Reid entered on a cold November day.

They found the stadium gate padlocked but discovered a broken window and climbed through for their unannounced inspection. What they found, surprisingly, was a still-viable stadium that needed only a few months of hard work to be made usable despite a decade of decay. Things moved quickly.

"Charlie Finley [A's owner] owned the Birmingham franchise outright and wanted to get out of direct ownership and have a standard player development contract," Thrift said. "Both Hitchcock and I felt that Chattanooga would be a great city to go to because of its history. But I wanted to meet the people. We agreed right away because I believed in the Reids, the help they had lined up and how much people in Chattanooga believed in baseball."

The spark that lit the fuse to professional baseball's return had happened barely a month before, when the stadium's custodian, the University of Tennessee, allowed a five-year option on the property to lapse. Realizing the opportunity was Woodrow W. "Woody" Reid, the founder and president of a salad-making firm that bore his name. At the commission meeting that brought the availability of the Engel Stadium site before the public, Reid and son Mark met two other potential investors who were attending for the same reason: local optician Jim Crittenden and attorney Arvin Reingold.

"Arvin and I went down to the commission meeting to suggest that we would like to bring baseball back," said Crittenden, who owns a chain of optical stores in the Chattanooga area. "The Reids were there as well. We'd never met, but someone suggested that we all get together to form a partnership. Over the next few days, we came up with a partnership everyone was happy with. Woody was chairman of the board. And Arvin and I narrowed it down to where we each owned 10 percent," recalled Crittenden.

Hitchcock took a quick telephone poll of the league owners, and within hours after the Reids officially obtained the lease, their new partnership with the Athletics was revealed.

Oakland owner Finley supplied that 1976 Chattanooga team with a number of high-energy players who could take advantage of the stadium's unique and spacious dimensions and gave

them a dynamic manager. A crowd of 8,305 turned out April 20 for the return of baseball to Chattanooga and Engel Stadium, an 8-3 win over Charlotte. Designated hitter Mark Budaska broke a 1-1 tie with a grand slam over the right-field wall, and Brian Kingman earned the win by allowing three runs (two earned) in seven innings. Kingman would enjoy the longer big league career but would become the majors' last 20-game loser of the 20th century.

The 1976 playoff run ended against a Montgomery team featuring future Detroit standouts Alan Trammell, Lance Parrish, and Dave Rozema, who defeated the Lookouts 2-0 in a one-game playoff. Rozema threw a five-hit shutout, and it would be 11 years before the Lookouts were in another postseason series. At year's end, Reid was named Minor League Executive of the Year.

The prickly Finley soon wore out his welcome in Chattanooga, even with the gentlemanly Reid. At the end of the 1977 season, the Lookouts announced a new player development contract with the Cleveland Indians and a change in the ownership group. Problems with the family business forced Mark Reid to sell out his share and Woody Reid to step back into a background role, turning the running of the franchise over to Crittenden.

While crowds were small, there were a few memorable moments in the years that followed, including three straight batting champs: Joe Charboneau, who a year later was American League Rookie of the Year, hit .352 in 1979; followed by catcher Chris Bando (.349 in 1980); and veteran infielder Kevin Rhomberg (.366 in 1981). Providing much of the home run pop during the Indians era was an Illinois native named Salvatore Rende. "Sal" was a talented left-handed hitter who was encouraged to sacrifice batting average in aiming for the inviting right-field porch. Rende was happy to go along but pointed out later that the mission wasn't simple.

"At first, I wasn't really a true pull hitter. But playing with that massive left-center, I wasn't going to hit home runs over there," said Rende, who hit 87 home runs in parts of five seasons with Chattanooga. "It affected my average a lot. But I don't know that I'd do anything different."

Rende made his residence in Chattanooga following his playing career and enjoyed two decades as a minor-league manager and hitting coach. He was even hired to manage the Lookouts in 1985.

Money problems began catching up with the Crittenden group in 1981. An article to that effect caught the eye of a potential buyer. "I had never seen a Lookouts game, but I saw an article in the paper where Crittenden was unhappy and wanted to sell," said Spring City, Tennessee, resident Harry Landreth, who like Crittenden was a self-made success as an area businessman and marketer. "I went to the 1981 World Series with Jim and we sealed the deal where I'd buy 40 percent of the team and assumed the debt. But I really didn't know how bad a shape they were in."

Landreth, an energetic gnome of a man whose true passion was the stage, committed fully to the role of franchise spokesman. Even now, he is quick to credit the late Ed Holtz, the club's general manager. "If not for Ed Holtz, I don't know what we would have done," Landreth said. "He was exactly what we needed at the time. I would have trusted Ed with any amount of money. I was so pleased with Ed's work I wound up giving him 10 percent of my share."

By 1982, Landreth had assumed 80 percent of the club's ownership, as Crittenden returned to merely being a fan.

"If I had the club today, it'd be more fun because I wouldn't have the debt," Crittenden said in hindsight. "Just recently my daughter told me how she takes great pride in telling her children that the Lookouts were once our family's team. It's especially gratifying because I grew

up watching baseball there. I was in Engel's Knothole Gang for two or three years, then Ruby Williams hired me to hawk peanuts and popcorn from a vendor tray."

Landreth lost his taste for baseball with the death of his father, who served as the stadium handyman. "My dad [Roland] loved baseball and loved being around the Lookouts," Landreth said. "When he passed away during the 1983 season, the party was over as far I as I was concerned. It became a business and a job; the fun wasn't there any more."

After the 1982 season, the Lookouts hooked up with the Seattle Mariners. A new era was about to begin, and the new "good old days" were about to be gone for good.

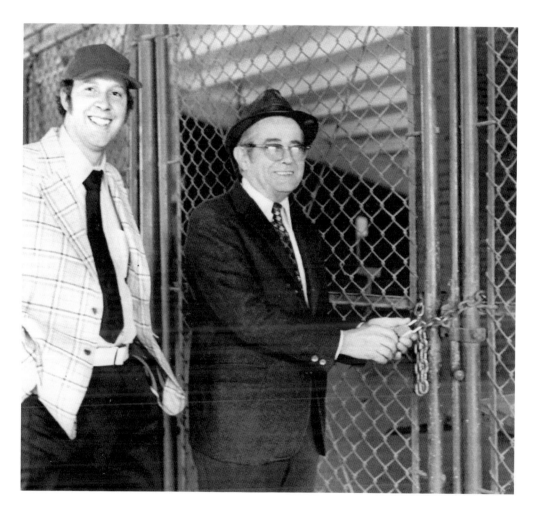

REIDS GET THE KEYS. New Chattanooga Lookouts owners Woody Reid (right) and son Mark try out the keys to Engel Stadium's front gate in 1976 after getting approval by the Southern League owners to relocate the Birmingham franchise. The Reids did not have a key the previous November, when they took league president Billy Hitchcock and Oakland farm director Syd Thrift on a tour of the stadium through a broken window. "We saw a lot of the old archives. We also saw a lot of pigeons," said Thrift. (Courtesy Lookouts.)

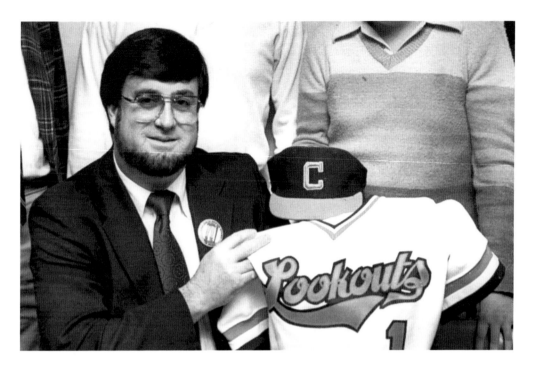

HONEST JIM? Adorned with an Abe Lincoln-esqe beard, local businessman Jim Crittenden became the principal owner of the Lookouts when Woody Reid's family business suffered a series of setbacks. "They had a bankruptcy. I had the money," explained Crittenden, who met Reid at the first commission meeting over the use of Engel Stadium in 1975 and was part of the initial ownership group. (Courtesy Lookouts.)

A GRAND SLAM. Forced to be designated hitter due to the strong outfielder fielded by the 1976 Lookouts, Mark Budaska still managed to be the club's Opening Day hero with a grand slam against Charlotte. (Courtesy Lookouts.)

A SECOND CHANCE

OPENING DAY ACE. Brian Kingman won the Lookouts Opening Day game when baseball returned to Engel Stadium in 1976. But the right-hander, who won 14 games for the Lookouts, is better known for losing 20 games for the 1980 A's. (Courtesy Lookouts.)

FRONT-OFFICE BOUND LIEPPMAN. After his playing days were over, infielder Keith Lieppman moved upstairs and in 2005 completed his 14th season as Oakland's director of player development in 2005. Lieppman hit .287 with only 38 strikeouts in 106 games for the 1977 Lookouts. (Courtesy Lookouts.)

BRYANT—THE SPIRIT OF '76. Minor-league veteran Derek Bryant emerged as the leader of the 1976 Lookouts, tying for the league lead in triples (10) and stolen bases (42). (Courtesy Lookouts.)

A SECOND CHANCE

COX A SUCCESS ON FIELD, IN DUGOUT. In an organization that loved to run, Cox made himself a top prospect of the Oakland Athletics by leading the Southern League in stolen bases (68) in 1977. The former Lookout returned to the Southern League as a manager and won the 1990 Southern League championship with the Memphis Chicks. (Courtesy Lookouts.)

TOUGH DUTY. Forest "Woody" Smith, a veteran minor-league third baseman and highly successful manager who won four straight pennants from 1969 to 1972 in Miami, found the Lookouts too tough a task. After three frustrating seasons in Chattanooga, Smith stepped away from managing and became a scout. (Alan Vandergriff photograph.)

JOLTIN' JOE. Outfielder Joe Charboneau, obtained from the Minnesota Twins before the 1979 season, took the Southern League by storm with a league-best .352 average. One year later, he became American League Rookie of the Year with the Indians. Two years later, injuries began his downslide, and he would return to the Lookouts in 1982. (Courtesy Lookouts.)

KEOUGH THE HITTER. The A's still thought of Matt Keough as a third baseman in 1976. But after hitting only .210 for the Lookouts, he was converted into a starting pitcher and led the Southern League in strikeouts (153) the following season. He would become a mainstay in the Oakland rotation from 1978 to 1982. (Courtesy Lookouts.)

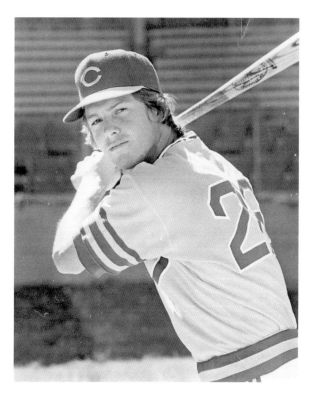

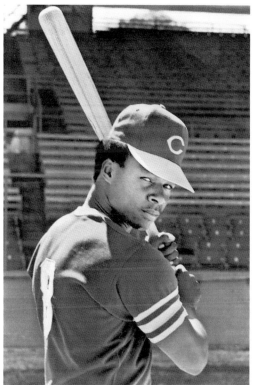

OUTFIELD EXCELLENCE. Dwayne Murphy had to battle for playing time while with the Lookouts, but his smooth defense was suited for Engel Stadium's vast outfield. That kind of preparation helped Murphy go on to win seven Gold Glove Awards in the major leagues, most of them with Oakland. (Courtesy Lookouts.)

SOON-TO-BE SUCCESS. A reliever during his two seasons with the Lookouts, Steve McCatty was converted into a starting pitcher soon after, leading the American League in wins (14) in the strike-shortened season of 1981. (Courtesy Lookouts.)

ALL-TIME FAVORITE. Outfielder Rick Colzie, brother of NFL star Neal Colzie, played for the Lookouts with both Oakland and Cleveland. Voted a member of the fans's 20-year most popular team in 1996, he stole 22 bases in just 75 games in 1978. (Courtesy Lookouts.)

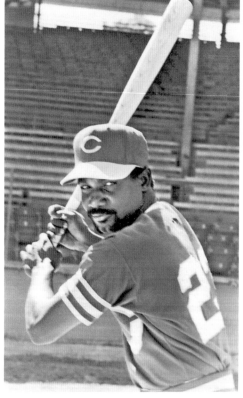

A SECOND CHANCE

BANDO BLOSSOMS IN 1980. Chris Bando had struggled through two injury-filled seasons for the Lookouts when he suddenly blossomed in 1980. His .349 average not only won the league batting title, but it was more than 100 points higher than he hit in 1979. (Courtesy Lookouts.)

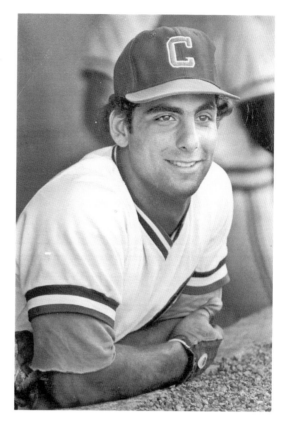

A PATIENT LOOKOUT. Shortstop Mario Diaz spent three years playing for the Lookouts (1983–1985) and had his patience pay off by reaching the majors in 1987 to begin a nine-year career there. Diaz played independent league ball until 1999 at age 37. (Courtesy Lookouts.)

ROOKIE OF THE YEAR. Connecting here, first baseman Alvin Davis set a Southern League record for walks (120) during the 1983 season. He moved directly to Seattle, where he was named the American League Rookie of the Year with the Mariners. (Courtesy Lookouts.)

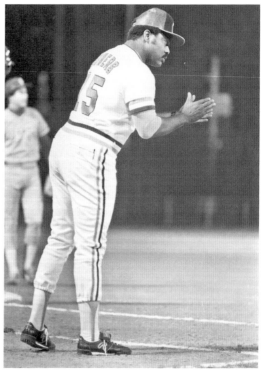

FIRST BLACK SKIPPER. Former Washington, D.C., policeman Mickey Bowers became the Lookouts' first-ever black manager in 1983, but he was fired midway through the season by the parent Seattle Mariners. (Alan Vandergriff photograph.)

INDIANS SWAN SONG. The Cleveland Indians' ended their five-year affiliation with the Lookouts in 1982. Notable Lookouts in the photograph include future Toronto all-star Kelly Gruber (first row, far right), modern-era homer champ Sal Rende (second row, sixth from left) and Southern League all-star pitcher Robin Fuson (third row, second from right). Manager Al Gallagher is on the far right of the second row, just in front of owner Harry Landreth and next to GM Ed Holtz. Minority owner Carrington Montage is at far left. (Courtesy Harry Landreth.)

THE 1983 LOOKOUTS. One of the most remarkable collections of future major-leaguers was sent to Chattanooga by new parent organization Seattle in 1983. Among those who would log notable time in the big leagues were Scott Nielsen, batting champ Ivan Calderon, and Dave Valle (first row, first three from left); Danny Tartabull and Robert Long (second row, third and fourth from left); Jim Presley and Alvin Davis (second row, sixth and fourth from right); Mario Diaz and Paul Serna (third row, first two from left); and Mark Langston (third row, second from right). Not pictured is Darnell Coles, already promoted to Triple-A. Team owners Carrington Montague (far left, not in uniform) and Harry Landreth (far right, not in uniform) flank Manager Bill Heywood (seated front row, center) and GM Ed Holtz (second row, second from right not in uniform). (Courtesy Harry Landreth.)

TARTABULL TAKES ON SECOND. Danny Tartabull hit 262 major-league homers as an outfielder with the Mariners, Royals, Yankees, White Sox, and Athletics. But he was a second baseman with the 1983 Lookouts, hitting .301 with 13 homers. Two years later, he was the Pacific Coast League MVP after hitting 43 homers in a friendlier Calgary ballpark. (Courtesy Lookouts.)

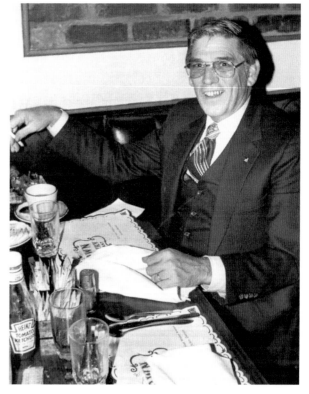

HIS HONOR. Jimmy Bragan, who finished the 1978 season as manager of the Lookouts, went on to serve 15 years as Southern League president, succeeding the retiring Billy Hitchcock. With his office located just outside of Birmingham, Bragan was a frequent visitor to Chattanooga. (Courtesy Lookouts.)

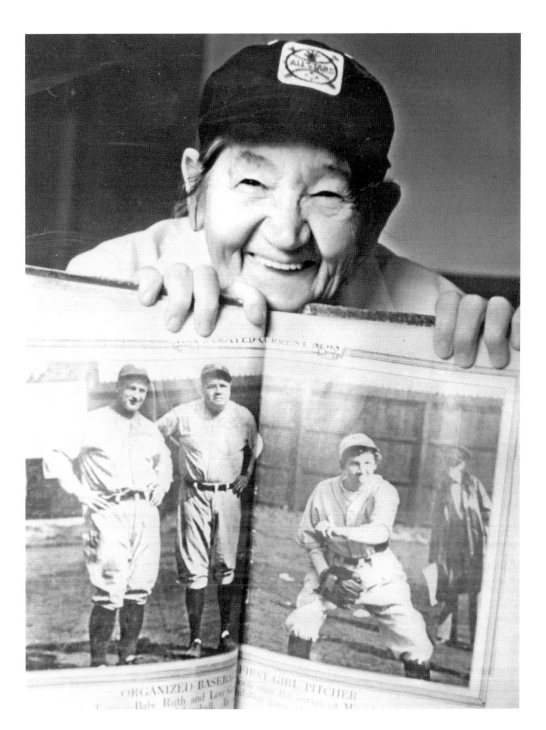

JACKIE'S 50TH ANNIVERSARY. Jackie Mitchell, shown holding one of her scrapbooks, was able to celebrate the 50th anniversary of her Chattanooga pitching debut against Babe Ruth and Lou Gehrig in 1931. She was brought out to throw out the first pitch of the season for the Lookouts and again became a national celebrity. (Courtesy author.)

BASEBALL IN CHATTANOOGA

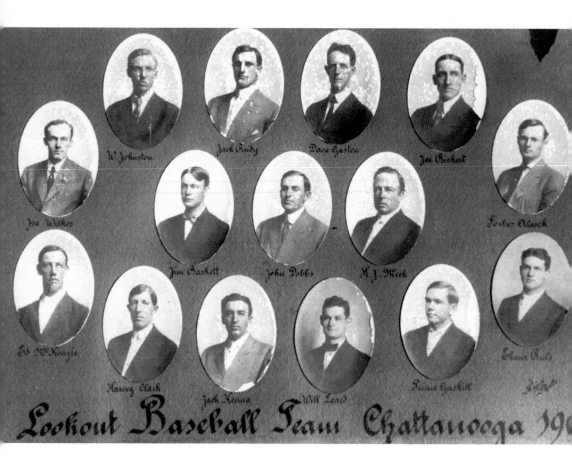

W. Johnston Jack Reidy Dave Gaston Joe Rickert

Joe Wilkes Jim Baskett John Dobbs H. J. Mook Foster Clark

Ed McKenzie Harvey Clark Jack Kenna Will Lear Renie Gaskill Elmer Gale

Lookout Baseball Team Chattanooga 190

CHATTANOOGA'S 1909 CHAMPIONS. Chickamauga, Georgia, native Johnny Dobbs (middle, center) managed the first Chattanooga team to enjoy a championship, winning the South Atlantic League in 1909. Forbes "Scotty" Alcock (top right) batted .349 and Jack Reidy (top row, second from left) stole 46 bases for the team, which had a remarkable 40-16 record in the first half-season. (Courtesy Lookouts.)

THE EARLY DAYS

Professional baseball came to Chattanooga in 1885, but the first team folded in July 1886. Another pro team arrived in 1889 only to have the Southern League fold on July 5 with a mere 38 games played.

The Southern League reformed in 1892, and Chattanooga remained part of it until 1895, when the franchise was moved to Mobile mid-season. That team won a first-half pennant in 1892 with what was described as an "all-Irish team." It was called the Sullivans after player-manager Ted Sullivan, who later managed in the major leagues.

The team carrying his name was sold to individuals in Mobile and claimed the league championship when Birmingham refused to play a ninth game after the teams split the first eight in their playoffs. League representatives later voted to award the championship to Birmingham based on its better regular-season record.

The original Southern Association was formed with a Chattanooga franchise in 1901. Again the city was able to hang onto the team for only two years, with Montgomery buying it away this time. But in 1909, a local group headed by O. B. Andrews brought a South Atlantic League franchise to Chattanooga and dubbed it the Lookouts, in reference to historic Lookout Mountain, which loomed over the city. Managed by Johnny Dobbs, a native of nearby Chickamauga, Georgia, the team played home games at Chamberlain Field on the University of Chattanooga campus.

The original Lookouts won the first half-season and entered into a playoff with second-half champ Augusta. The Lookouts won the 1909 playoff in Augusta despite suspicions that the home team had tampered with their drinking water. The winning pitcher was future major-leaguer Al Demaree, who was added to the Lookouts in time for the playoffs. That led to a protest by Augusta and a league ruling allowing his eligibility. Three years later, Demaree pitched 18 innings in one game for Mobile and struck out 20 batters.

In 1910, Chattanooga rejoined the Southern Association when Andrews's group bought the Little Rock franchise, including all of its players, for the bargain price of $12,000. Dobbs managed that team before moving on: He managed Southern Association teams for 23 seasons and won 1,841 games. The Lookouts moved into newly upgraded Andrews Field, next to the city's busy rail yard.

It was a pitcher-dominated era. Harry Coveleski, who would go on to a nine-year career in the big leagues, had a 28-9 record in 1913. In 1915, Rube Marshall worked a record 332 innings, including 23 in one game, and was part of a record-setting week when the Lookouts won seven consecutive games by shutout. One of those wins was a forfeit, but the run included 53 consecutive shutout innings.

The year before, Jeff Clark made an entry into the league record book by throwing 18 shutout innings in both ends of a doubleheader against Atlanta. He won the first game 1-0, but the second game was suspended after nine innings with the score 0-0 and replayed.

Fred Graf, an infielder, made his Lookouts debut in 1913 and led the team in home runs with four. That marked the beginning of a career that will likely never be matched in the Southern Association/League. Graf played off and on in Chattanooga into the 1920s, played in the Southern Association until age 35, and established several league marks for longevity, including most games (1,523), most putouts for a third baseman (1,708), and most total chances (4,902). His favorite memory—a story he often related—was driving in the winning run against Birmingham pitcher Burleigh Grimes, a former Lookouts teammate and future Hall of Famer, while Grimes was attempting an intentional walk. As the game ended, Grimes grabbed the baseball and threw it over the grandstand.

Graf made his home in Chattanooga following his playing days and was the Opening Day honoree to throw out the first pitch in 1978. He died in November 1979 at the age of 90.

Chattanooga's top slugger of the pre–Engel Stadium era was, like most of his successors, a left-handed hitter: Elliott "Babe" Bigelow, who remains one of the minor league's all-time top run-producers. In 1926, Bigelow hit .370 with 118 RBIs in Andrews Field. After two seasons playing for the Birmingham Barons and a year with the Boston Red Sox, he returned to Chattanooga in 1931 and made Engel Stadium his stomping grounds by batting .372 with a league-leading 125 RBIs, still the team record. But following the 1932 season when he played in Knoxville, Bigelow died of meningitis at the age of 35.

Bigelow eclipsed the power production of John Anderson, who led the team in home runs for three successive years (1922–1924) by hitting 10, 14, and a league-best 26.

O. B. Andrews and partner Z. C. Patten Jr. had sold the park bearing Andrews's name to Lookouts president Sammy "Strang" Nicklin during the 1919 season. Nicklin was an ideal candidate to run the Chattanooga club: his father, John B. Nicklin, was president of the 1880s Southern League and of the newly formed Southern League in 1902–1903.

A native Chattanoogan, the younger Nicklin (known as Sammy Strang during his major-league playing days) followed a 10-year big-league career with seven years coaching West Point's fledgling baseball team. He retired from the army having never lost to Annapolis, and he once posted a lineup that included future generals Omar Bradley, Mike Mitchell, and Bob Neyland. Neyland, who would become better known in Tennessee as a highly successful coach of the football Volunteers, was Nicklin's pitcher.

Nicklin passed up a $5,000 offer to continue coaching at West Point as a civilian. Instead he bought the Lookouts and ran the team until 1929, selling out and retiring to a life of leisure at the age of 55. He died in Chattanooga in 1932.

THE EARLY DAYS

UBS on Line Service

1-888-279-3343

KC 134,84

UP 2658.49

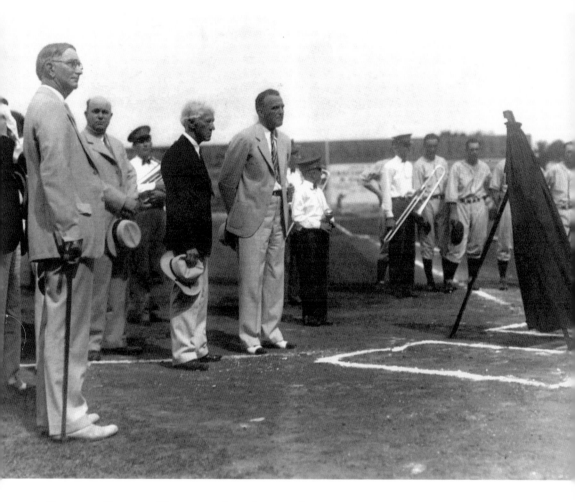

A Day for Nicklin. Three months after former-Lookouts owner and manager Sammy Strang Nicklin passed away, Joe Engle (center) held a day in his honor. Among those present to honor the New York Giant and lifelong Chattanoogan were Mayor Edwin Bass (left) and commissioner Kenesaw Mountain Landis (left of Engel). The black cloth covered a plaque of Nicklin's accomplishments that hung at Engle Stadium for many years. (Courtesy Joe Engel collection, the Baseball Hall of Fame and Museum, Cooperstown, New York.)

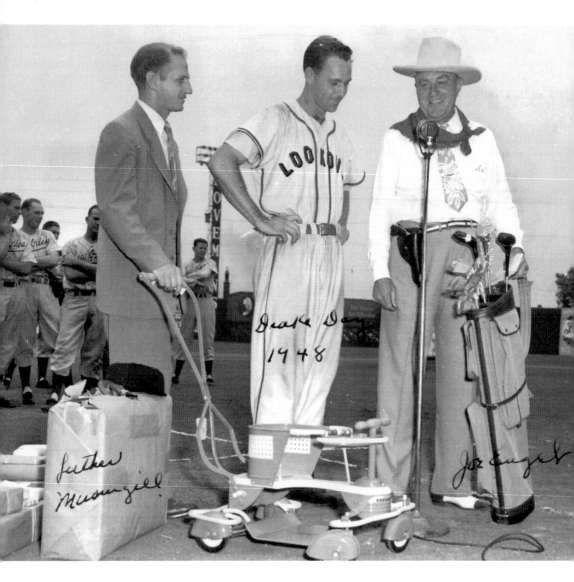

A Day for Larry Drake. Joe Engel took great pleasure giving special days honoring standout players and managers during his time running the Lookouts. Late in the 1948 season it was outfielder Larry Drake's turn. Cowboy Joe (right) presents the Texan with a set of golf clubs, while public address announcer Luther Masingill wheels up a stroller for the new father. In his only season with the Lookouts, Drake set club records for home runs (30) and a hitting streak (37 games) that still stand. (Courtesy Joe Engel collection, the Baseball Hall of Fame and Museum, Cooperstown, New York.)

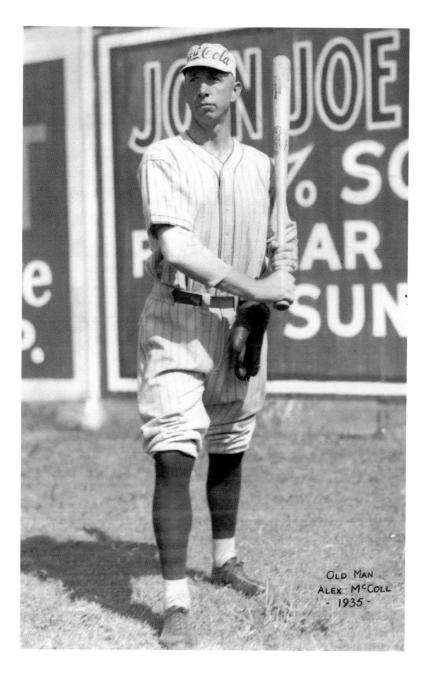

OLD MAN
ALEX M^cCOLL
- 1935 -

"OLD MAN RED." There is no debate: Alex "Red" McColl remains the Chattanooga Lookouts's all-time greatest pitcher. Pictured here in 1935 when he won 21 games for the Lookouts at age 42, he was the hero of the Lookouts' only Dixie Series champion in 1932. He won three games and saved one in a 4-1 series win over Beaumont. McColl, who won 70 regular season games for the Lookouts, pitched for 26 minor league seasons until the age of 47 and lived to the age of 98. (Courtesy Joe Engel collection, the Baseball Hall of Fame and Museum, Cooperstown, New York.)

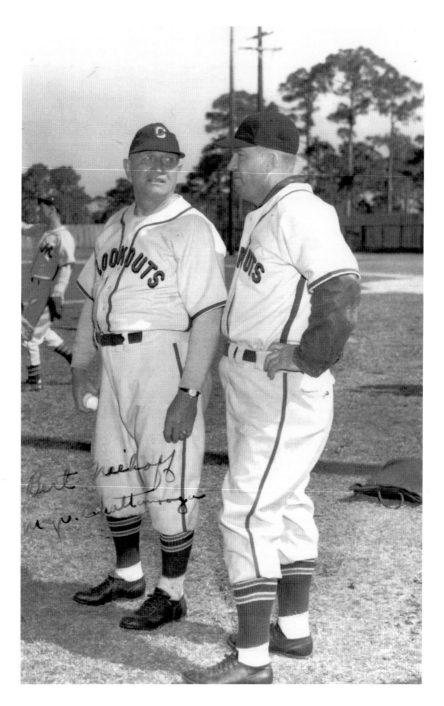

NIEHOFF THE SKIPPER. Bert Niehoff, who originally managed the Lookouts from 1931–1933, returned in 1945 after two years managing the Women's Professional Baseball League. Niehoff (left, with Joe Engel during spring training in Winter Garden, Florida) took the Lookouts to the Southern Association playoffs in 1945, 1946, and 1947. (Courtesy Joe Engel collection, the Baseball Hall of Fame and Museum, Cooperstown, New York.)

ENTER JOE ENGEL

ENTER JOE ENGEL

Rumors were running hot and heavy in Atlanta the summer of 1929. Their Crackers, a long-established minor-league franchise, were headed into receivership under the ownership of Rell (R. J.) Spillner, and a young scouting director from Washington named Joe Engel was in the city with (rumor had it) an offer in his pocket from the Senators' Clark Griffith to buy the club.

So it surprised officials in two cities when Engel approached Lookouts owner Sammy Strang Nicklin and his partners with the stunning offer to not only buy the franchise, but to replace Andrews Field and all its shortcomings with a "modern stadium that would be a credit to Chattanooga and the entire Southern League."

Little is known about what happened with Engel's Atlanta deal, but with the promise of a new stadium sealing the deal, the Lookouts were sold to Griffith, and Engel Stadium was hurriedly constructed to replace Andrews Field by the following (1930) season. Dubbed Engel Stadium, the new park was built for $180,000 on the same site as Andrews Field. But in order to better accommodate hitters and fans in their battle with the late-afternoon sun, home plate was flipped to face the opposite direction—leaving the late-afternoon sun to torment generations of right fielders.

Well known throughout baseball as Griffith's right-hand man, Engel had gone from being a washed-up pitcher to serving as a one-man scouting staff. His first notable signing was a key member of the Senators in future player-manager Bucky Harris. But his biggest pickup was future Hall of Famer (and American League president) Joe Cronin.

As pitcher, Engel was washed up by 1918, only 25 years old. But during an earlier stint in the minor leagues, Griffith had called Engel for an opinion on a catcher he was interested in purchasing, and Engel's report was dead-on. Griffith did not forget, immediately hiring the washed-up pitcher as his first and only national scout. That role grew to where Engel was Griffith's point man on the establishment of his Southern Association franchise.

The 1930s featured one of the best-known Lookouts ever, Cecil Travis, as well as one of the best-ever forgotten players, Ray Treadaway. Travis, who has many backers as one of baseball's best players not enshrined in the Hall of Fame, hit .356 and .352 in his two seasons in Chattanooga, then followed that with five straight .300-plus seasons in the big leagues. Treadaway, a third baseman, had a club-record 210 hits and batted .367 for Engel's first team in 1930. He would reach the majors at age 22, find himself out of baseball at age 25 despite four straight .300 seasons, then died at age 27 from a shooting on a Chattanooga street following a beer-fueled argument.

Remarkably Engel's only championship came in 1932. The regular season ended with Chattanooga at 98-51, .002 percent better than Memphis (101-53). Commissioner Kenesaw

Mountain Landis would play a role in that pennant, overruling the league to allow Chattanooga to finish a suspended game with Knoxville (which they won to move ahead of Memphis).

The Lookouts' 1932 drama had its turning point on September 2. Bill Andrus homered and scored from second on a long fly ball to defeat Knoxville. But Andrus wrenched his knee at home when he failed to slide. The Senators sent Dave Harris down from the majors to fill in, and Harris would deliver in a big way, hitting .421 with 18 RBIs in only 10 games. In the controversial makeup game, a 13-5 win over Knoxville, Harris went 4-for-6 with a pair of home runs and seven RBIs, and a new league rule soon followed, outlawing September roster additions for "first division" teams.

The Lookouts would go on to win their first and only Dixie Series by defeating Beaumont of the Texas League four games to one. Alex McColl, named the Lookouts' best pitcher between 1900 and 1950, won three games and saved one. He had a four-hit shutout in game two, a one-inning relief stint win in game three when Chet "Popeye" Wilburn, who had been released by Beaumont two years earlier, had a game-winning RBI double. McColl put out a ninth-inning fire to save game four, then (after a travel day) five-hit a Beaumont team that included future Hall of Famer Hank Greenburg in its lineup. Harley Boss, who would go on to coach baseball at Vanderbilt University, went 4-for-4 in the clincher.

The Lookouts celebrated with a quick trip to nearby Mexico. Engel could not suspect that he would never enjoy another postseason championship, although he would be part of the franchise for another 34 years.

The 1939 pennant race was nearly as memorable. They needed to win one of two games on the final day to clinch and instead swept Knoxville on "KiKi Cuyler Day," which honored the club's popular first-year manager. The highlight of the day (aside from the clinching) was Engel "forcing" Cuyler, at gunpoint, to sign his contract for 1940. The Lookouts were 83-65, one percentage point better than Memphis (84-65).

"I knew all along we would win," Engel said. "I just thought it would be closer."

But fourth-place Atlanta swept the first round of the new league playoffs (not played in 1931).

In 1938, a local partnership acquired the franchise from Griffith after he reassigned Engel and sent his son Calvin to run the Lookouts. That group had money problems, and Griffith bought the team back in 1941 but kept Engel in place. In mid-1943, Griffith moved the club to Montgomery due to a number of problems running the day-to-day operation in Chattanooga, including a sharp decline in attendance. However, Engel orchestrated a letter-writing campaign by Chattanooga fans, and Griffith agreed to return the franchise back to Engel Stadium that December.

In the 1940s, Griffith hired Italian-born scout Joe Cambria to mine the rich vein of Cuban ballplayers. The Lookouts had 14 Cubans on their 1944 roster, including batting champion Rene Monteagudo, but 1945 belonged to non-Cubans, pitcher Larry Brunke and outfielder Gil Coan. Brunke won his final nine decisions in the regular season for a franchise record 15-1 mark and added another win in the playoffs. Coan led the Southern Association in hits (201), doubles (40), triples (a franchise-record 28), home runs (16), stolen bases (37), and average (.372). Two years later, the Senators sent him back to Chattanooga, where he added a 17-triple, 22-homer, 42-steal, and .340 average before returning to the big leagues for good.

Two football All-Americans played for Engel. Auburn product Jimmy Hitchcock (brother of future SL president Billy) was a standout infielder on the 1938–1939 teams. Alabama's Fred

Sington hit .384 in 1936—a club record that still stands. Legendary pitcher Bobo Newsom, who pitched for Griffith 15 years before, got another crack at the big leagues thanks to two strong seasons anchoring the Lookouts' rotation in 1949 (when he won 17 games) and 1950.

In 1948, outfielder Larry Drake set a franchise record that still stands with 30 home runs and a club-record 37-game hitting streak.

GOOD FRIENDS, BETTER RIVALS. It's doubtful that Joe Engel had a bigger rival or better friend than Atlanta Crackers president and later owner, Earl Mann (left). A master promoter in his own right but less outrageous than Engel, Mann became the Crackers' club president in 1935 and their outright owner in 1949. He turned over control of the Crackers to the Southern Association in 1959—the same year that Calvin Griffith gave up the Lookouts. Mann did retain ownership of historic Ponce de Leon Park until it was auctioned off and demolished in 1965. Mann, who was nicknamed "The Baseball Genius of Dixie," died in 1990. (Courtesy Joe Engel collection, the Baseball Hall of Fame and Museum, Cooperstown, New York.)

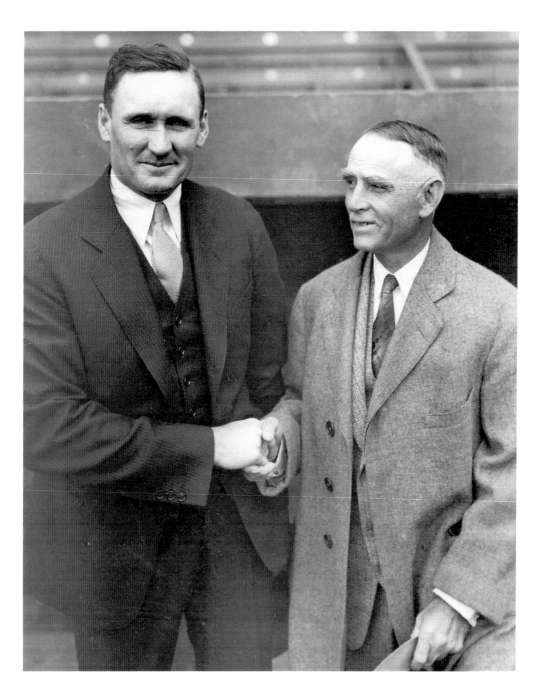

ENGEL'S INFLUENCES. More than any other two men in baseball, Joe Engel admired and respected these two Hall of Famers. Pitcher Walter Johnson (left) was Engel's roommate during his brief major-league stay with the Washington Senators. Clark Griffith, owner of the Senators, employed Engel as a player, scout, minor league club president, troubleshooter, and possibly even a role model for his son, Calvin. (Courtesy Joe Engel collection, the Baseball Hall of Fame and Museum, Cooperstown, New York.)

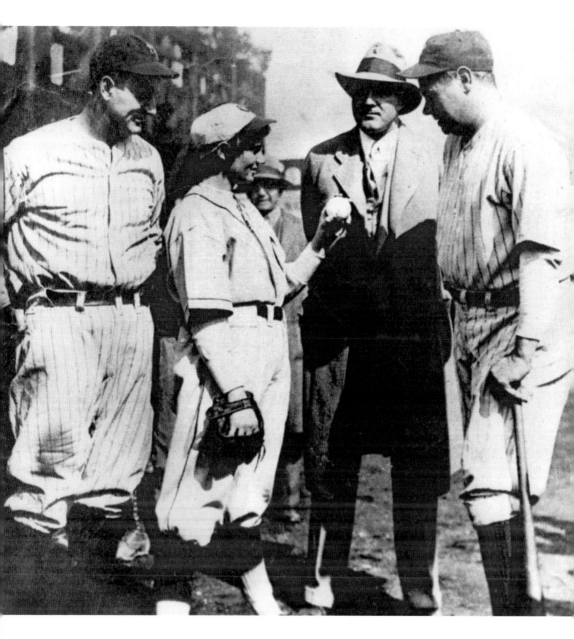

YANKEES EYE ENGEL'S PRODIGY. Yankees greats Lou Gehrig and Babe Ruth sized up the competition—in this case, diminutive left-handed pitcher Jackie Mitchell—as Lookouts president Joe Engel looked on before Mitchell's historic performance in the teams' 1931 exhibition game. Mitchell, who relieved Clyde Barfoot in the first inning, struck out Ruth and Gehrig and walked Tony Lazzeri before Manager Bert Niehoff re-inserted Barfoot. Commissioner Kenesaw Mountain Landis voided her contract days later. (Courtesy Lookouts.)

BASEBALL IN CHATTANOOGA

BOBO THE LOOKOUT. Fourteen years after first being named an American League All-Star, journeyman pitcher Bobo Newsom (right) gave the Lookouts two seasons of duty in 1949–1950. Newsom (shown with catcher Jake Early) won 30 games and averaged 236 innings per season. Joe Engel honored him with Bobo Newsom Day in his final Chattanooga start; he would be ejected from that game, but would wind up back in the major leagues two seasons later. (Courtesy author.)

OWNER OF EPIC SEASON. Few players enjoyed their stay in Chattanooga more than Gil Coan. While hitting a league-best .372 in the 1945 season, the North Carolina native had 84 extra-base hits, including 40 doubles, a league-record 28 triples, a Southern Association–leading 16 homers, and a league-best 42 stolen bases. He would follow that by hitting .340 with 42 steals for the 1946 Lookouts and subsequently played in the majors until 1956. (Courtesy author.)

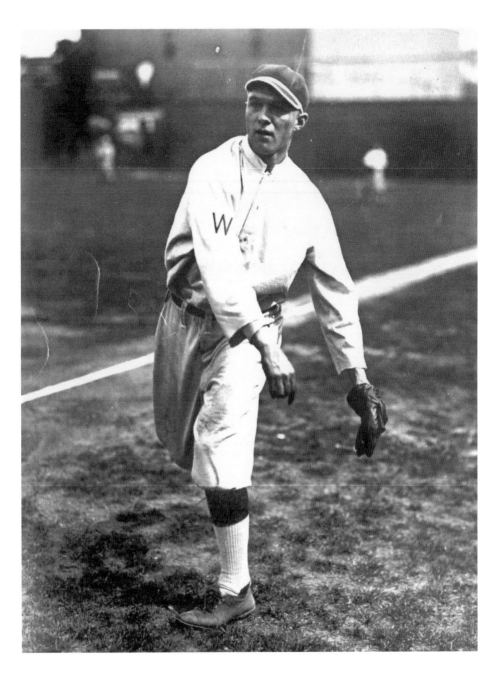

Now Pitching: Joe Engel. Following an outstanding career, young right-hander Joe Engel reached the big leagues at age 19, pitching for the 1912 Washington Senators. Arm trouble followed his best season of 7-5 in 1914, and Engel would go on to make brief stops with Cincinnati and Cleveland. But during his final days pitching in the minors, Senators owner Clark Griffith began to appreciate Engel's ability to evaluate talent and consulted with him on several trades while Engel was still an active player. (Courtesy Joe Engel collection, the Baseball Hall of Fame and Museum, Cooperstown, New York.)

ENTER JOE ENGEL

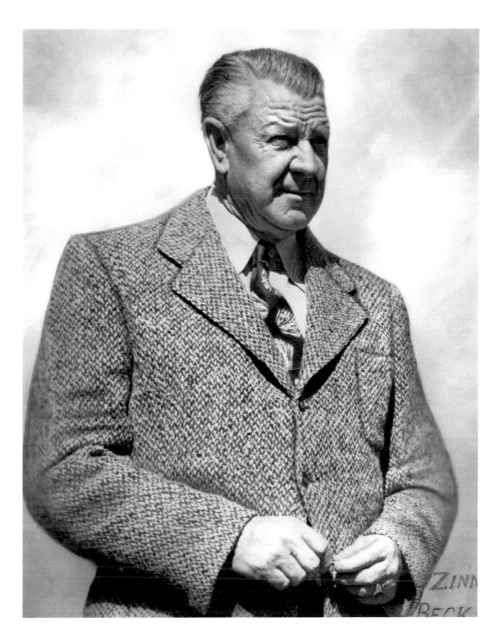

RIGHT-HAND MAN. Zinn Beck served as Joe Engel's general manager and chief scout for much of his long reign running the Lookouts. Beck, whose big-league career ended in 1919, managed in the minor leagues for much of the following 20 years and guided the Lookouts for part of the 1934 season but was principally Engel's right-hand man through the 1950s. Among the players Beck signed for Chattanooga was fan-favorite Junior Wooten. Zinn was also owner of his own bat company in South Carolina and had Hall of Famers Rogers Hornsby and KiKi Cuyler (who both would also manage the Lookouts) among his clients. (Courtesy Joe Engel collection, the Baseball Hall of Fame and Museum, Cooperstown, New York.)

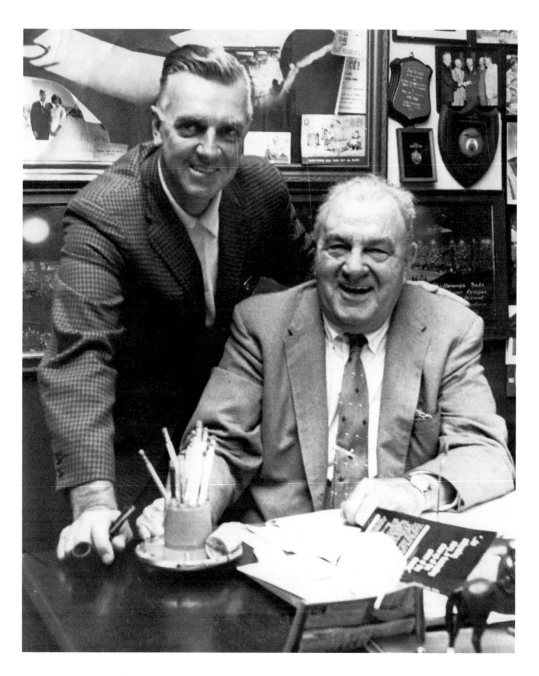

WINNING TEAM. The architects of the finest season in Chattanooga Lookouts history were manager Cal Ermer (left) and owner/president/general manager Joe Engel. Ermer, brought to Chattanooga after winning 100 games in Charlotte in 1951, guided the Lookouts to the 1952 regular-season championship with an 86-56 record. They lost in the playoffs, but 252,000 spectators came through Engel Stadium's turnstiles for a club record that still stands. Ermer would manage through the 1957 season, and Engel would give up control of the franchise two years later. (Courtesy Lookouts.)

ERMER ARRIVES

There was little to cheer about in Chattanooga following the Lookouts' 1939 regular-season title.

There were back-to-back Southern Association batting titles by Rene Monteagudo (.370 in 1944) and Gil Coan (.372 in 1945). Coan also set an all-time club record with 28 triples. Outfielder Earl "Junior" Wooten had 195 hits in 1949, and otherwise-ineffective pitcher Lou Bevil threw a pair of no-hitters.

From 1948 to 1951, the Lookouts failed to finish higher than seventh in an eight-team league. Following an eighth-place finish in Jack Onslow's only season in 1951, Engel finally got his man—Charlotte manager Cal Ermer.

The 27-year-old player-manager was coming off an unforgettable season, going 100-40 with a Class A Hornets team (also owned by Clark Griffith) that was voted one of the top 100 of all time by minorleaguebaseball.com.

Engel and Ermer first met when Ermer spent time in Chattanooga following World War II getting back in playing shape. Ermer got an offer to play in Orlando and then clashed with him over a contract figure:

> I sent it back, twice, and he finally sent me a note that said, "sign it or stay home." So I finally signed, came down and was working out in the spring. Ganzel saw me and asked me if Engel kept his word about his contract. So Ganzel took me to see Mr. Griffith and told me to tell him my story. I did, and Griffith said that Joe should have kept his word.

"Griffith wrote something on a note and told me to give it to Engel. I was naive enough to do it," Ermer said. "So I did, and Joe said, 'Well, okay. Go see Mr. [Zinn] Beck [Washington's general manager] tomorrow and he'll give you a new contract. I did, signed the contract and Beck said, 'By the way, we just sent you to Charlotte.' "

He would spend three of the next four seasons with the Hornets, taking over as manager in 1947 when Spence Abbott, the club's current skipper, had taken ill.

Ermer gave up his playing career upon joining the Lookouts, but he had been productive, hitting .297 and driving in 77 runs in his final season (1950) wearing both hats.

Said Ermer, "That was the best year I'd ever had. But Mr. Griffith told me not to play when I got there because they'd finished last four years in a row and wanted me to concentrate on managing the team. Plus, Engel told me I needed to get rid of [veteran Ellis] Clary. I said, 'What? Why? He was the best player on the team.' Engel said, 'Yeah, but I kind of promised the manager's job to him.'

Instead Ellis Clary joined Ermer as a veteran cornerstone to the lineup, winning the league MVP title a year later. In addition, he had two of his key players join him in Chattanooga. Catcher Bob Oldis, who would have the longest major-league career of any of the 1950 Hornets,

played four years in Chattanooga and later would be part of Ermer's coaching staff during his stint managing the Minnesota Twins. Outfielder Bruce Barmes, a career .318 hitter, had only five games in the majors but was a fixture in the Lookouts' lineup from 1953 until late 1957, hitting .300 the first three years and picking up 716 hits.

Ermer's arrival coincided with the arrival of one of the Lookouts' all-time favorite players, first baseman Roy Hawes. The big left-handed hitter, who settled in nearby Ringgold, Georgia, as a permanent resident, provided a power boost to the lineup with 20 homers and a team-leading 93 RBIs.

"Cal and I are about the same age, but it was strictly business with him. We didn't become close friends until after my playing days," Hawes recalled. "As long as you did your job, he'd never say anything. If you loafed, he'd be all over you."

Three Chattanooga starters on the 1952 regular season championship team were members of the Atlanta Crackers' 1950 Southern Association pennant winner: player-coach Clary, shortstop Gene Verble, and legendary outfielder Ralph "Country" Brown.

During the 1952 season, the potent Lookouts lineup set a record by picking up 11 consecutive hits in one inning against Little Rock. Ironically the Lookouts were being no-hit with one out in the fourth inning when Barmes began the historic hit parade. He and Brown would have two hits in the streak, while Hank DiJohnson had the only home run in the 10-run inning.

Clary was the "daddy of the club," according to Hawes. "He was the only person Cal could really confide in, and he was always right alongside."

Another fixture on Ermer's team was 6-4 center fielder Don Grate. A college All-American in basketball at Ohio State, Grate had tried both pitching and the NBA with no success before arriving in Chattanooga in 1951 as a strong-armed outfielder. He drew national attention to himself and the Lookouts by breaking the accepted world record for the longest baseball toss by throwing one 443 feet, 3-and-a-half inches in 1952. A year later, he beat his own record by an inch. He would lose it in 1957, to former big-league outfielder Glen Gorbus. The new record throw went 445 feet, 10 inches.

Engel would see his turnstiles spin at a record rate in 1952, as a total of 252,703 fans turned out for the pennant-winning regular season. However, the Lookouts lost four straight to Memphis in the Southern Association playoffs.

In 1955, an 80-74 regular season was good enough for third place in the league, but the Lookouts, led by Jim Lemon's 109-RBI season, lost in the first round of the playoffs four games to two against Birmingham. But in that year's mid-season all-star game, Lemon set a Southern Association record by hitting four home runs in Birmingham's Rickwood Field.

That season was clouded by the death of Clark Griffith. His adopted son, Calvin, took over the Senators but soon began pleading poverty as a precursor to moving the franchise to Minneapolis.

In 1957, Ermer's final season with the Lookouts, an 83-70 record put the Lookouts in fourth place, allowing them the chance to scare the regular-season champion Atlanta Crackers by winning twice in the first round of the playoffs before being eliminated.

"I think Cal got more out of his players than just about any other manager I ever played for," said Hawes.

That final club gave Ermer a chance to manage one of the Senators' most expensive bonus babies, a slugging third baseman who was not intimidated by Engel Stadium's distant left-field

wall. In fact, when Harmon Killebrew was inducted into the Baseball Hall of Fame, he would tell writers that hitting a league-leading 29 home runs that 1957 season ranked among his biggest accomplishments.

With Birmingham in 1958, Ermer won both the regular-season championship and the playoffs. For his career, including playoffs, Ermer won a total of 2,150 games in the majors and minors, including a record of 487-457 with the Lookouts.

Ermer, still a Chattanoogan, is scouting for the Twins at age 81.

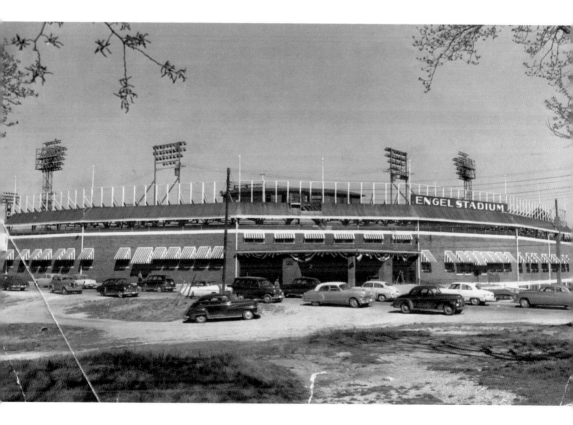

ENGEL IN ITS PRIME. In its prime, Engel Stadium (shown here in the early 1950s) was a spic-and-span example of a minor-league showcase stadium. Note the stairs to the press box above the entranceway. The club's all-time attendance record was enjoyed in 1952, when over 252,000 fans saw the Lookouts post the Southern Association's best record. (Courtesy Lookouts.)

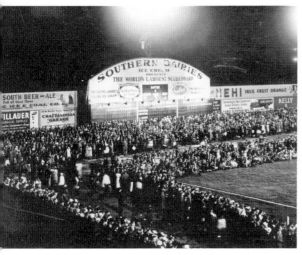

ENGEL'S RECORD CROWD. While the largest gathering in Engel Stadium history was for a Billy Graham Crusade, the Lookouts' single-game attendance record came on the team's first-ever night game in May 1936. Joe Engel arranged for a newly built house to be given away to a lucky

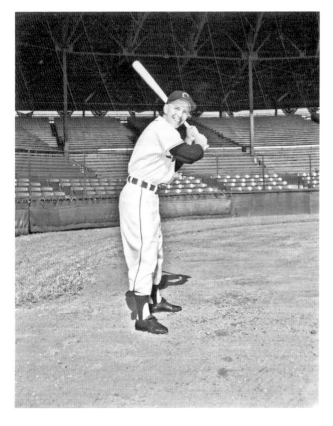

GOLDEN GLOVE. Despite standing only 5 feet 4 inches, Ernie Oravetz stands tall as one of the best outfielders to ever handle Engel Stadium's concrete right-field wall. Undaunted by his return to Chattanooga in 1957 after two seasons with the Senators, Oravetz wound up playing 679 games for the Lookouts, amassing over 2,500 at-bats and 783 hits with a .309 average on top of his defense. (Courtesy author.)

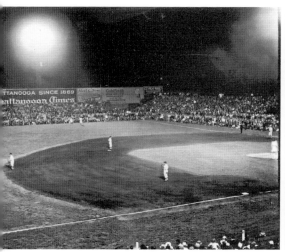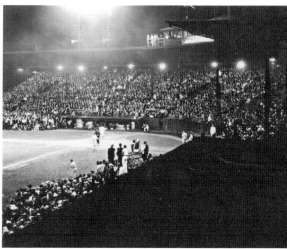

fan, and the crowd, announced at just over 24,600, showed up. (Courtesy Chattanooga Regional History Museum.)

COUNTRY GENTLEMAN. Ralph "Country" Brown, a member of the Georgia Sports Hall of Fame, spent much of his career with the Atlanta Crackers but joined the Lookouts in time to be part of the 1952 regular season championship team. Brown was from Summerville, Georgia, only 50 miles south of Chattanooga. (Courtesy author.)

CUBAN ANGELS. While the color barrier in the Southern League remained virtually intact until the league folded, the Senators routinely assigned light-skinned Cubans to Chattanooga. Two who had good stints with the Lookouts were reliever Angel Oliva (top left), who appeared in 118 games between 1958–1959, and shortstop Angel Fleitas, who played more than 600 games for Chattanooga from 1945 to 1949 (with a 15-game side trip to Washington in 1948). Fleitas' brother Andres was a Lookouts' catcher from 1948-1951 and was later named to the Cuban Baseball Hall of Fame. A total of 14 Cubans were on the Lookouts' roster in1944, including league batting champ Rene Monteagudo. (Courtesy author.)

GRATE'S GREAT ARM. An All-American basketball player at Ohio State, Don Grate had already tried life as an NBA player and as a pitcher before he arrived in Chattanooga for the 1951 season as a converted outfielder. At the end of the 1952 season, Grate set a record for a thrown ball when he unleashed a throwof 443 feet, 31 1/2 inches.(Courtesy author.)

A PAIR OF FAVORITES. Although they were teammates for just one season (1955), Roy Hawes (left) and Jim Lemon (right) remain two of the era's most popular players. Hawes, who remains a resident of the Chattanooga area, played for the Lookouts for six seasons between 1952 and 1960 and remains the club's all-time home run king with 101. Lemon, who went on to spend 12 seasons in the major leagues, had a memorable year in Chattanooga, leading the Southern Association in RBIs (109) and triples (12). He hit 24 home runs during the regular season, but set the league single-game homer record in a unique manner_hitting four in the mid-season all-star game. (Courtesy author.)

CAPABLE CLARY. Veteran player-coach Ellis Clary closed out his 18-year minor-league career with the Lookouts, hitting .311 for the 1952 Southern Association regular-season champions and winning the league's Most Valuable Player award at age 35. He would remain active in baseball as a scout until his death in 2004. (Courtesy author.)

LOOKOUT MAINSTAY. Bruce Barmes had only five at-bats in the majors but racked up over 2,300 at-bats for the Lookouts from 1953 to 1957, three times hitting over .300 after following Manager Cal Ermer from a history-making Charlotte team that put up 100 wins in 1951. (Courtesy author.)

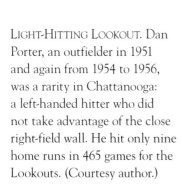

LIGHT-HITTING LOOKOUT. Dan Porter, an outfielder in 1951 and again from 1954 to 1956, was a rarity in Chattanooga: a left-handed hitter who did not take advantage of the close right-field wall. He hit only nine home runs in 465 games for the Lookouts. (Courtesy author.)

ERMER ARRIVES

BASEBALL LIFER. Infielder Vern Morgan spent his entire adult life in baseball and a big chunk of his career with the Lookouts. He played in nearly 600 games between 1956 and 1960 for Chattanooga, amassing 587 hits and a .294 average. Following his Lookouts years, he became a minor-league manager and later a coach for the big-league Minnesota Twins (formerly the Senators). He died following the 1975 season, awaiting a kidney transplant. (Courtesy author.)

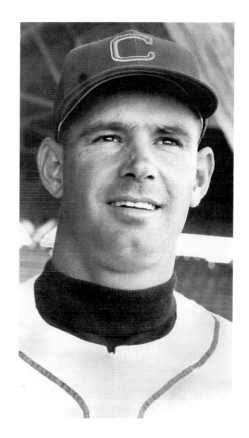

HITTING CHAMP, 1956. Lookouts third baseman Stan Roseboro, who had hit .400 in the low minors, became the Southern Association batting champion in 1956 by hitting .340. Roseboro, who had only two homers despite the friendly right-field wall, never reached the majors; his 35 errors in 109 games may provide a hint why. (Courtesy Lookouts.)

A 20-GAME WINNER. Hal Griggs first appeared in a Lookouts uniform in the 1954 season, but he would become the club's most recent 20-game winner with a 21-12 mark in 1957. He would enjoy a final go-round with the Lookouts in 1960 at age 32 but helped the 1961 team win the pennant by beating the Lookouts' closest pursuer while pitching for Macon. (Courtesy author.)

SUPERB SONNY. Right-handed pitcher John "Sonny" Dixon served two tours of duty with the Lookouts (1947–1948 and 1951–1952). His 19-2 season in 1952 was the catalyst for a four-year career in the big leagues with the Senators, Athletics, and Yankees. His minor-leage career stretched from 1941 to 1960, including time served during World War II.

"SNAKE-EYES." Modern-day baseball is not likely to see a career minor-leaguer like Charley "Snake-Eyes" Letchas. The scrappy infielder had four stints spanning more than 20 years with Joe Engel's Lookouts: 1938–1941, 1947, 1949–1950, and 1952. Letchas was the only man in uniform for both the 1939 and 1952 regular-season pennants. He collected 894 hits in Lookouts uniforms, playing 833 games. (Courtesy author.)

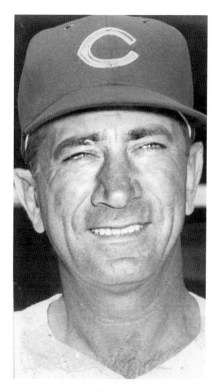

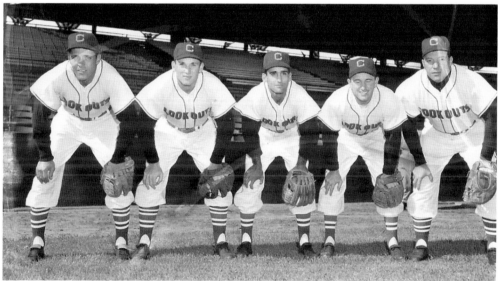

THE BEST, WORST OF LOOKOUTS. The 1957 Chattanooga infield would include the franchise's most famous and infamous players. From left to right are Tony Roig, future Hall of Famer Harmon Killebrew, Waldo Gonzalez, 1956 batting champ Stan Roseboro, and Jesse Levan. In 1959, by which time Killebrew was already in the majors, shortstop Gonzalez and first baseman Levan were suspended for conspiring to tip off pitches. (Courtesy author.)

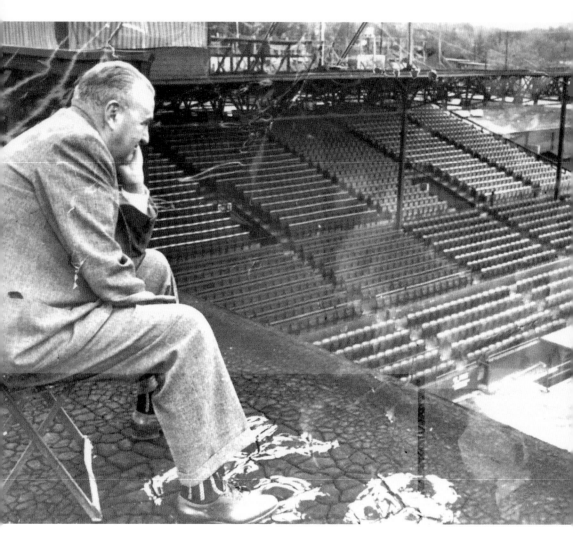

DAYS OF DECLINE. During one of his final seasons running the Lookouts, a downcast Joe Engel surveys the playing field from his accustomed spot atop the roof. The empty stands did not look much different during the games, as the final season (1965) saw only 25,707 fans come to see what turned out to be a last-place team. The final home game was designated "Save the Lookouts Night." It drew a paid crowd of 355. Al Raffo, a pitcher on the team and later a longtime prep coach, told the *Chattanooga Times*, "That team, or the quality of that team, kept people from coming to the ball park." (Courtesy Chattanooga Regional History Museum.)

5

DECLINE AND LEVAN

Jesse Levan was a cornerstone of the Lookouts in the late 1950s. Joining the club in 1956, the former minor-league batting and home-run champion was a veteran left-handed batter that was close to a sure thing for 100 RBIs per season. He drove in 114, 114, and 90 in each of his first three seasons, never missing more than four games a season. His contributions forced incumbent first baseman Roy Hawes into the outfield.

In 1959, Levan was still his slugging self, batting .337 through 75 games when the 32-year-old veteran's career came crashing down in flames. A new teammate, former Mobile Bears player Sammy Meeks, told Chattanooga player-coach Ray Holton that Levan had approached him in Mobile about tipping pitches during a series there earlier in the season. Holton quickly notified manager Red Marion, and an investigation began immediately.

Meeks's allegations were that Lookouts shortstop Waldo Gonzalez would tip the hitter what pitch was coming. Birmingham player Andy Frazier happened upon the meeting and agreed to accept signs. Meeks refused the offer of a payment, figuring that his duty was to help his team win by any means possible. That stance, and his quick action upon joining the Lookouts, allowed Meeks to escape suspension.

The "fix" was a non-event. Twice Meeks relayed signs to Frazier after getting a signal from Gonzalez, but neither tip-off accurately called the pitch. After two bad signals, Frazier subsequently ignored further signs. That lack of accuracy kept Gonzalez from receiving a lifetime ban.

Southern Association president George Troutman issued official reprimands to Meeks, Frazier, and Lookouts pitchers Bob Heise and Tom McAvoy. Gonzalez, a Cuban native, received a one-year suspension. Troutman ruled Levan was guilty of "acting as a liaison agent for batting interests and offering fellow club members money to throw games." Levan, who admitted attempting to put his teammates in touch with gamblers but denied any attempt to fix games, unsuccessfully appealed.

Heise testified that Levan approached him on two occasions, once at the start of the season and again later on, asking "if he wanted to make a little easy money" by delivering easy-to-hit pitches. Both times he made it clear he had no intention of being involved. But because of his refusal and friendship with Levan, he decided on his own not to report the bribes. McAvoy said that when Levan approached him in Mobile about possibly throwing a game, the way it was conveyed struck McAvoy as a joke and he dismissed it.

Veteran Lookout Roy Hawes was not part of the scandal, but he was one of the players who was brought in under top-secret circumstances to testify. Hawes recalled recently:

> We wondered at the time what was going on because they made us take sportscoats to Nashville in the middle of the summer. Trautman was there, the FBI was there. They asked me what I would do if I knew someone on the team was throwing games. I

said that I'd turn him in because that's not the way I played. I never knew anything for sure, but some things would happen that made you wonder. Once I had to chase down a throw in left field that Levan threw towards second but missed by a mile. I can't say he did it on purpose, but again, it was one of those things that made you wonder. They investigated the thing pretty well. Only those two players were suspended, but there were several players who quit who might have been involved.

"Others in the league were involved," Levan told a newspaper in 1989. "Their case broke prematurely. It wasn't what (the investigators) thought it would be, and somebody had to get hung for it."

That season brought the Senators' relationship of over 30 years to a close. Left-hander Jim Kaat had an 18-strikeout performance for the Lookouts. Hawes returned to the club after a three-year tour of the minors and hit .299 with 16 homers. Heise was a strong part of the rotation, finishing fifth in the league in ERA (2.83).

Calvin Griffith, whose family had owned the Lookouts outright for 30 years (except one season where a local group attempted a failed ownership), put the Lookouts up for sale. The Philadelphia Phillies signed a new player development contract for 1960, and club president Engel brokered a deal where Griffith sold Engel Stadium to the city and county governments. The franchise was operated by the Lookouts Booster Club and overseen by local businessman Tommy Lupton.

On the field, an unlikely club record was set by some even more unlikely performers in 1960. Relief pitcher Bob Greenwood, outfielder Bert Hamric, first baseman Alan Grandcolas, and third baseman Gair Allie all homered in the same inning against Shreveport.

The last hurrah for the Southern Association, 1961, allowed Engel to enjoy one more pennant. The Phillies sent club manager Frank Lucchesi and a battling team that won the regular-season title late by winning 12 of 13 games leading up to the clinching. The capper was a 10-inning win in Shreveport, decided by a 5-run inning that included John Herrnstein's 17th homer. That home run tied a club record at the time by being the 94th by the team.

The Lookouts' attendance for the season was only 107,000—albeit an 88 percent increase from 1960. The Southern Association, suffering from small crowds in many cities as well as local laws that made integrating the league problematic, folded at the end of the regular season and failed to hold playoffs for the first time since 1933. Despite a pledge by the Phillies to remain affiliated, the Southern Association's collapse led to the absence of baseball in Chattanooga for a year.

The Phillies quietly broke the Lookouts' color barrier when they returned in 1963 to the upgraded South Atlantic League, assigning Hank Allen, Adolfo Phillips, and Bobby Gene Sanders to the Opening Day roster. Allen, brother of Phillies rising star Richie Allen, would be gone after four games to return in 1964, but Sanders, who was the top defensive second baseman in the league, played in 103 games, and Panamanian outfielder Phillips, who would go on to enjoy eight seasons in the majors, hit .306 in 121 games. The following season would introduce local fans to pitchers Grant Jackson and Canadian-born Ferguson Jenkins, who would become the Lookouts' newest Hall of Famer. Jenkins returned to Chattanooga in the late 1990s as a roving instructor for the Reds. Jackson would also return, 25 years later, to serve as the Lookouts' pitching coach.

But two years later, with a last-place team failing to draw any fans, Engel (citing the growth of live television and air conditioning) declared a fatal decline in attendance and disbanded the franchise. He would die four years later.

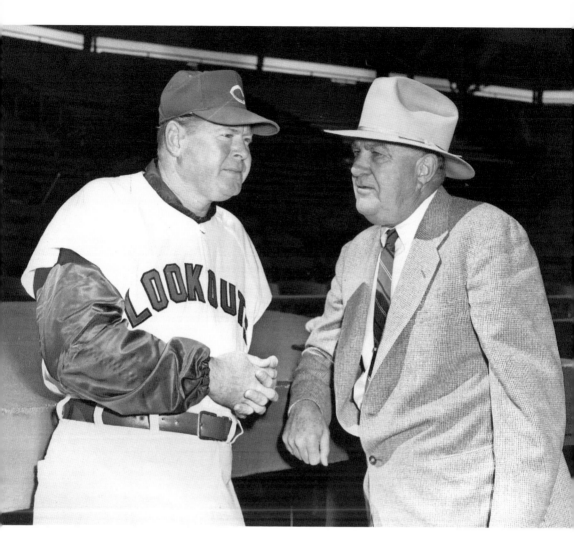

ERMER'S SUCCESSOR. Former Lookouts outfielder "Red" Marion (in uniform) had a lot to talk about with boss Joe Engel. Marion, the brother of Cardinal great Marty Marion, had to deal with the Jesse Levan scandal but got a chance to manage future stars Jim Kaat and Harmon Killebrew during his 1958–1959 tenure. (Courtesy author.)

YOUNG KILLER. Senators bonus baby Harmon Killebrew spent all of 1957 and most of the 1958 season with the Lookouts, and he showed his Hall of Fame credentials early by hitting a league-leading 29 home runs in 1957 despite the daunting left-field wall and scoreboard. Following his induction to the Hall of Fame in 1984, Killebrew told the media that the Southern Association homer title was among his toughest accomplishments. (Courtesy author.)

LONG, LEAN LEFTY. Pitcher Jim Kaat was only 9-9 during his only season with the Lookouts (1959), but he previewed his future major-league greatness by striking out 18 hitters in one game. Kaat retired with 283 major league victories. (Courtesy author.)

TWINS' HALL. Jimmie Hall hit .245 as a 21-year-old infielder with the 1959 Lookouts. Moved to the outfield, he began his big-league career in 1963 by hitting 33 home runs for the Minnesota Twins. (Courtesy author.)

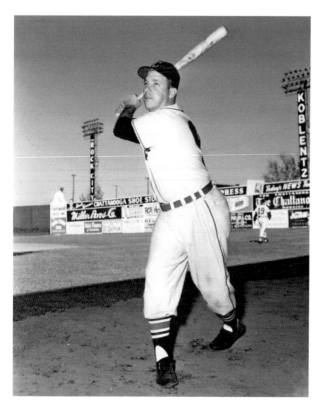

BANNED LEVAN. Slugging first baseman Jesse Levan was a crowd favorite in Chattanooga, hitting 83 home runs in three-and-a-half seasons. But the 33-year-old veteran became a baseball exile when he was banned for life in 1959 for planning to tip off pitches to an opposing team. (Courtesy author.)

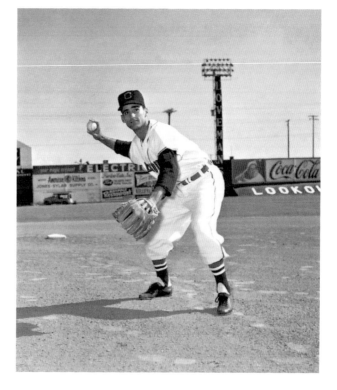

THE NOTORIOUS WALDO. Shortstop Waldo Gonzalez, who had been putting in service time with the Lookouts since the 1956 season, was suspended for a year for his role in the pitch-tipping scandal that ended Jesse Levan's career. Gonzalez departed for Cuba almost before he could be missed, but he returned to play in Salt Lake City in 1961. (Courtesy author.)

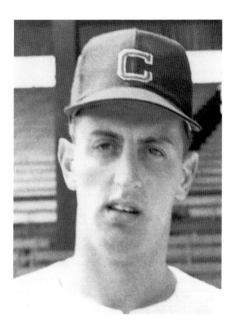

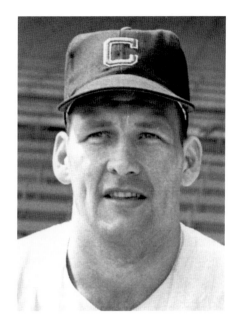

CALLED ON THE CARPET. Lookouts pitchers Jim Heise (left) and Tom McAvoy avoided suspensions in 1959, but just barely, in the Jesse Levan scandal. Heise refused to go along with Levan but failed to initially report the plot, citing his friendship with Levan, while McAvoy indicated that he thought it was only a joke. Both pitchers escaped with stern reprimands from Southern Association president George Trautman. (Courtesy author.)

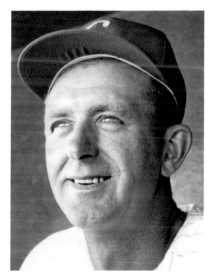

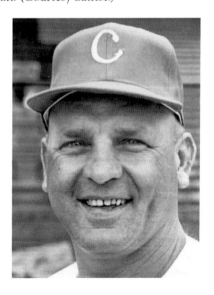

THE 1960S SKIPPERS. The final years of the Joe Engel era were far from successful. Jack Phillips (left) managed the Lookouts to a 62-78 record in 1963, and former Phillies catcher Andy Seminick managed only a 125-154 record, good for seventh- and eight-place finishes in his 1964–1965 tour of duty. (Courtesy author.)

SECOND-GENERATION HOPEFUL. Infielder Dickie Harris, the son of legendary big-league player/manager Bucky Harris, was a hopeful young prospect for the Lookouts at the onset of the 1958 season. But like so many second-generation hopefuls, his dream died hard. He was cut from the Lookouts after hitting .147. (Courtesy author.)

SPOOK SENIOR. Forrest "Spook" Jacobs was player-manager for the Chattanooga Lookouts in 1960, when they finished eighth (60-93) in the Southern Association. The former major-leaguer enjoyed more success on the field, as his .306 average tied for sixth-best in the league. His son, also nicknamed Spook, would later umpire in the Southern League. (Courtesy author.)

FAMILIAR FACE, STRANGE ATTIRE. Cal
Ermer showed up at Engel Stadium in 1958
wearing strange attire: the uniform of the
Birmingham Barons. Ermer managed the
Barons to a 91-52 regular season record
and the overall championship with an 8-2
playoff record. Ermer's Barons eliminated the
Lookouts in the first round of the Southern
Association playoffs. (Courtesy author.)

GRAHAM CRACKED DOUBLES. Wayne
Graham set the Lookouts' single-season
record for doubles (51) while hitting .332
for the 1961 Southern Association champs.
He would later become a coaching legend
at Rice University, winning over 600
college baseball games. (Courtesy author.)

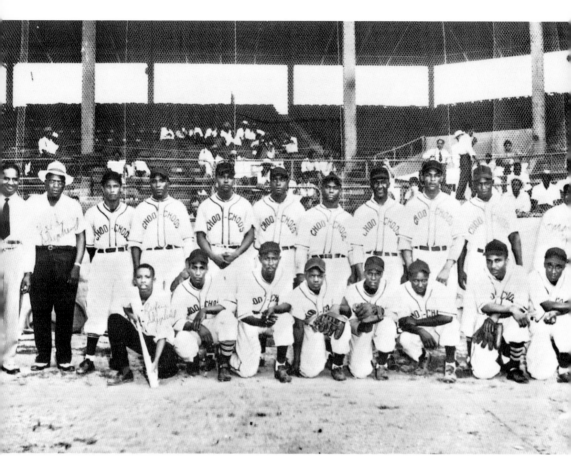

WILLIE AND THE CHOO CHOOS. A teenaged Willie Mays (first row, fourth from left) was not allowed to sign a contract, but the 16-year-old spent much of his summer playing for the Chattanooga Choo Choos. Owner Beck Shepherd (second row, second from left) had to disband the team after bad weather disrupted a key road trip. Shepherd, whose family remains Chattanooga residents, later would run a shoe shine stand on Ninth Street (now Martin Luther King Jr. Drive). (Courtesy Chattanooga Regional History Museum.)

THE FIRST BLACK
LOOKOUTS

The Southern Association's historians claim that the league had a long, proud history before its demise before the 1961 playoffs. But the Southern Association's dirty little secret is that several teams (or the cities that housed them) refused to allow the inclusion of Negro ballplayers years after Jackie Robinson broke the major-league color barrier.

In fact, only one black player was ever officially part of Southern Association roster, but Nat Peeples lasted less than a week with the Atlanta Crackers and never played a home game.

Chattanooga, like several of those segregated-minded cities, filled that void by intermittently hosting a professional team of Negro players. The Chattanooga Black Lookouts were a charter member of the Negro Southern League in 1920, but the team lasted only one season. The club, owned by local businessmen Bo Carter, Bud Haley, and W. C. Hixson, was re-established in 1926 for a two-year run. One member of that 1926 team (which was called the White Sox) was a pitcher named LeRoy "Satchel" Paige.

A boy phenom newly turned professional, he made his professional debut at Andrews Field on May 1, 1926, and began a two-year run of near-invincibility.

"I lost two games in two years. The only way they could have beaten me was to pass a law," Paige claimed in his book, *Maybe I'll Pitch Forever*.

That club, which was a farm team of the Homestead Grays—a historic franchise in its own right—folded after 1927, even though the Negro Southern League thrived until 1932.

Paige, however, considered what would have been a historic return several years later. According to his book, then-owner Strang Nicklin offered Paige $5,000 if he would paint his body white and start a game against the Atlanta Crackers.

Never one to pass up an opportunity, the pitcher actually mulled over the idea before friends talked him out of it. Later he would say that he hated to give up all that money.

"White, black, green, yellow, orange—it don't make any difference," Paige wrote. "Only one person can pitch like me. That's Ol' Satch himself."

The Negro Leagues would not officially return to Chattanooga until the 1940 season, when owner/operator Beck Shepherd formed the Chattanooga Choo Choos. Shepherd went broke in 1946, shutting down the Choo Choos in the middle of a road trip but not before he had a chance to use a 16-year-old outfielder named Willie Mays on a busman's holiday away from his hometown of Birmingham.

As Shepherd told it, he discovered Mays literally playing baseball in a cow pasture in Alabama. Due to his age, Mays did not sign a contract with the Lookouts, but played for them in parts of the 1945 and 1946 seasons, leaving only when the club suddenly ceased operations.

"Yes, I discovered Mays," Shepherd told *Chattanooga Times* sportswriter Buss Walker in 1954.

"I saw him go get some hard-hit balls and then saw him get rid of them. Even then he was a natural ballplayer—a great player. I said to myself right then, 'Get this boy to play on your Choo Choos and you've got it made. He's the best."

"I wanted to sign him, but his mother wouldn't agree. She thought he ought to go to school," Shepherd added. "I told her than in five year's time he could buy himself his own school. A half-dozen of them, if he wanted. She let me have Willie to play ball with the Choo Choos, and I kept him two years before I went broke. He traveled all over the country with my club. I had my own bus and we traveled from Texas to Canada, playing as we went."

Shepherd estimated he was $17,000 in the hole when he suddenly shut down the Choo Choos, never again to compete in any Negro League.

"Hard luck set in early that year. We were traveling down through Texas when a snowstorm caught us at Amarillo on Easter Sunday and we couldn't play," Shepherd recalled. "From there on, bad weather followed us, right on up through the Midwest and into Michigan. Snow and rain, expenses piled up all the time. I'd gone broke, and when we got home, I gave the bus to one of the schools, split up the squad and told them to go for themselves."

When Walker found Shepherd for a remarkable interview, he was running a shoe shine parlor, but his son and grandson still live in Chattanooga in 2005.

While Choo Choos team photographs that include Mays are display in more than one local museum in Chattanooga, a copy of the photograph sold on eBay in 2005 for the princely sum of $2,770. "Say hey" indeed.

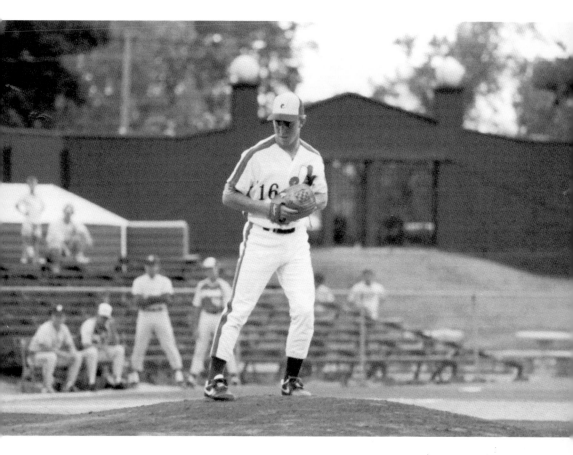

Old-Time Entryway. Engel Stadium's old Negro League entrance (shown behind Jacksonville pitcher Brian Barnes during a Southern League All-Star Game) remained a symbolic gate until damaged by an auto accident in the mid-1990s. (Courtesy Lookouts.)

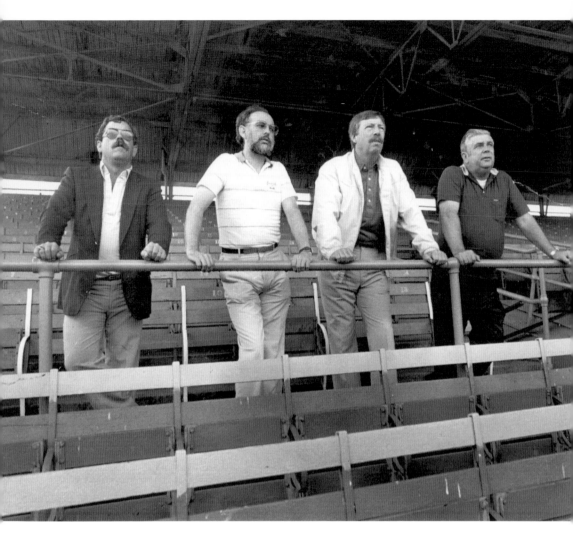

YUILL TAKES THE TRANSITION TOUR. The transition takes place. Outgoing Lookouts owner Harry Landreth (second from left) views the Engel Stadium playing field with new owner Bill Yuill (second from right). They are flanked by Yuill assistant Russ Williams (left) and Lookouts general manager Ed Holtz. (Courtesy Lookouts.)

TROUBLED TIMES . . . AND A TITLE

TROUBLED TIMES . . .
AND A TITLE

The five years the Seattle Mariners provided players to the Lookouts can best be summed up by the 1983 team. With a roster that included 14 past and future big leaguers, the team had a losing record. Talent was apparent; Donnell Nixon set the all-time Southern League stolen base record (102), and the Lookouts produced two more batting champs in Dave Myers and Brick Smith.

The Mariners regularly put top picks like pitcher Erik Hanson in Chattanooga right away; nothing worked and no Seattle-era team reached the playoffs. During that period (1983–1987), the aloof Bill Yuill surprised many by selling the team.

After almost no interacting with Yuill, Chattanooga baseball fans suddenly found themselves with another club owner who made more headlines than the team on the field. But unlike Joe Engel, most of Rick Holtzman's headlines were negative.

Holtzman was a major player in minor-league baseball ownership when he paid Yuill more than $1 million to acquire the Lookouts in time for the 1987 season. Already owner of the Triple-A Tucson, Class AA Midland (Texas), and the Class A Quad Cities (Iowa) franchises, the Chicago-based architect had designs on owning his own system.

A team normally reflects its manager's personality, and that would certainly be true of the Lookouts' 1988 team, the only championship club of the modern era. Tom Runnells, former utility infielder, brought a single-minded desire to win (a plus) and an overbearing us-versus-them mentality (not so good). A competitor to the core, the 33-year-old Runnells was a former state tennis champion in his native Colorado.

Perhaps more than any other club of the modern era, the 1988 Lookouts, the first team to be affiliated with the Cincinnati Reds, were all about pitching.

Chris Hammond would win 16 games and set an all-time club ERA record of 1.72. Keith Brown departed for Triple-A with a 9-1 record, while Scott Scudder was unbeatable over the second half, logging a 7-0 record. In the bullpen, Ivy Leaguer (Columbia) Joe Bruno had seven wins and a 1.21 ERA, while Jim Jefferson set a league record the first week of the season when he struck out eight consecutive Charlotte hitters. For the season, the Chattanooga staff had a dazzling 2.80 ERA in a pitching-dominated league where no team had an earned run average as high as 4.00.

The Lookouts would win the first half in the Eastern Division in a one-game playoff with Knoxville, winning 11-1 at Engel Stadium in a game that owner Holtzman indicated was a referendum on the future of baseball in Chattanooga. A crowd of over 5,500 turned out to see Bruno throw four hitless innings of relief while Darren Riley and backup catcher Buddy Pryor drove in three runs apiece.

The Lookouts, again with Bruno as the relief hero, won the division playoff series against Memphis (managed by ex-Lookout Sal Rende) three games to one. The clincher was won 3-1 as Keith Lockhart and Don Wakamatsu had RBI hits and Bruno threw two-and-two-thirds innings of hitless relief. He was the only reliever Runnells needed in the series as Hammond, Scudder, and Mike Smith each threw a complete game in the first three.

The championship series against the Greenville Braves was an appropriate ending to the season. The three-game sweep was capped by a 13-2 victory and a sixth-inning, full-on brawl between teams that saw the Braves pitcher, Maximo Del Rosario, helped off the field. Del Rosario's crime was hitting Brian Lee Finley with a pitch after Finley had earlier stolen a base with Chattanooga already ahead 7-1. Finley and bench player Luis Reyna were ejected while Braves third baseman Ed Whited suffered an injured ankle in the melee.

The championship game would be the last played in Engel Stadium before an extensive renovation that was only partly successful. The sight lines of the press box needed severe changes, while a third-base side restaurant featured a window that looked out on concrete steps that blocked the view of the playing field. A legal battle was waged over the field's drainage system, with Holtzman winning a judgment in court that led to it being redone.

Runnells, who would move on to briefly manage the Expos and Tigers, would continue to manage for years in the minor leagues.

The Reds, whose affiliation with the Lookouts continued into the 2006 season, provided only average-to-awful teams between 1989 and 1991. Despite that, the manager at the time, Jim Tracy, has gone on to manage in the big leagues for both the Los Angeles Dodgers and Pittsburgh Pirates. Ron Oester, a mid-season appointment for promoted skipper Dave Miley, had a powerhouse 1992 Lookouts team that won 90 games in the regular season but had to face a Greenville Braves team that won 100 games in the finals. Greenville won the championship three games to two. The final playoff game, won by a Mike Kelly homer, was played before the largest playoff crowd in Southern League history (6,113).

With the physical appearance of the old ballpark considerably improved, Holtzman expected a big bump in attendance. To that end, he replaced competent Bill Lee, a Yuill hire, with a former Sporting News Minor League Executive of the Year named Bill Davidson, most recently Holtzman's GM in Midland.

"Holtzman felt Chattanooga should be doing better financially than they were doing," Davidson recalled. "It was a much bigger ballpark than I was used to, 6,000 seats at Engel Stadium compared to 3,000 at Midland, and it looked like it needed a few coats of paint. Weathered is a good word for it, and while it wasn't uninviting, it was not in an attractive physical location for a stadium. But on game night, once you were inside, it was wonderful."

Davidson brought in several time-tested promotions that were still new to Chattanooga. "More than anything, I remember our first Used Car Night. I had no idea how well it would go over in Chattanooga and we were completely overwhelmed," Davidson said. "We had no idea that 9,000 people would show up. I remember standing on the roof and seeing traffic backed up and stopped in every direction."

There was the ill-fated Diamond Dig Night that failed to uncover—ever—a real, buried diamond in the Engel Stadium infield. But the masterstroke of promotion came when Holtzman and Davidson, perhaps sparked by a conversation Davidson had with his predecessor, Bill Lee, commissioned a new logo for the team.

"Our timing was dumb luck," Davidson said. "But no doubt about it, it was a big boost to our marketing."

Davidson left the Lookouts in September 1995, and now he runs a national sports consulting business in the Chattanooga area. Holtzman, however, disappeared without a trace as Burke and other creditors sought the fallen millionaire.

"Rick Holtzman was once a big name in minor league baseball," Davidson said. "I would be interested to find out what he's doing and what he's done. Working for him was good experience for the real world."

CATCH HIM IF YOU CAN. Like older brother Otis, Lookouts outfielder Donell Nixon broke stolen-base records at multiple levels. Despite hitting only .269, Donell shattered the Southern League record in 1984 with 102 steals, one season after setting the California League career record with 144. (Courtesy Lookouts.)

A SOLID HITTER. Big first baseman Brick Smith (his real name) dominated the Southern League in 1986, winning the batting title with a .344 average and driving in 101 runs even though the Lookouts had the worst overall record in the league (64-78). (Courtesy Lookouts.)

MYERS MANAGED TO MAKE IT. A versatile infielder-outfielder, Dave Myers rewarded the Mariners and Lookouts when given a regular position, third base, in 1987 by winning the Southern League batting average (.328). Myers became a minor-league manager two years later and amassed more than 700 wins through 2005. (Courtesy Lookouts.)

HAPPY DAYS! The feeling wouldn't last, but it was a celebration at Engel Stadium on Opening Day 1989 when Southern League president Jimmy Bragan (center) awarded the 1988 championship trophy to GM Bill Lee (left) and Owner Rick Holtzman. To date, it is the Lookouts' most recent championship. (Courtesy Lookouts.)

PLUM AND R. J. Bill Plummer (above) has spent 20 years as a minor-league manager, including a two-year stint in Chattanooga (1981–1982). As a player, he was best known for being Johnny Bench's principal backup. The son of Seattle's top scout, R. J. Harrison (left) guided the Lookouts for one season (1984). He was ushered out so that the Mariners could bring in hometown favorite Sal Rende. (Courtesy Lookouts.)

RENDE RETURNS. After hitting 87 home runs for the Lookouts, Sal Rende got the equivalent of a season-long curtain call when named the club's manager in 1985. The Lookouts were only 66-77 that season, but Rende has gone on to serve as a minor-league manager and hitting coach for the last 20 years. (Courtesy Lookouts.)

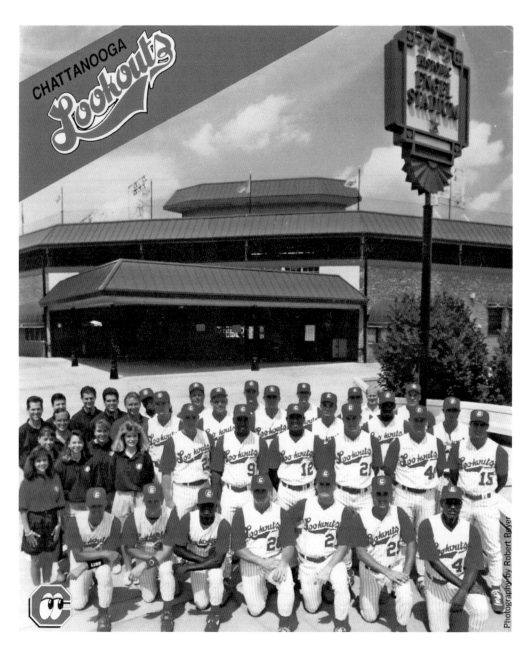

NEW LOOK LOOKOUTS. The Lookouts showed off Engel Stadium's new look in its 1993 team photograph. Among those pictured here in uniform are future major-leaguers Steve Gibralter and Pokey Reese (first row, second and third from left), Keith Gordon (second row, third from the left), John Courtright (second row, far right), and Brian Koelling (partially obscured on fourth row). Guiding the team to the playoffs were pitching coach Grant Jackson, 20 years after playing for the Lookouts and Manager Pat Kelly (fourth row, first and second from the left). (Courtesy author.)

TROUBLED TIMES . . . AND A TITLE

MARTINEZ BORN TO HIT. Known now as perhaps the best designated hitter in the history of the position, Edgar Martinez was considered by Lookouts fans a good defensive player as the everyday third baseman for two full seasons (1985–1986). (Courtesy Lookouts.)

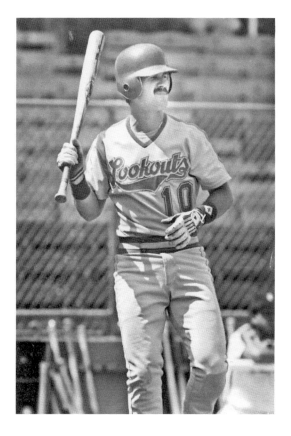

UNBEATEN LOOKOUT. Scott Scudder, the Reds' No. 1 pick in the 1986 draft, spent the second half of 1988 with the Lookouts, and the Texan proved to be a big part of that championship with a 7-0 record. (Courtesy Lookouts.)

STEELY STARE. A steely gaze from Manager Tom Runnells was a familiar sight throughout the Lookouts' 1988 championship season. The former utility infielder (and high school tennis champion) later managed the Montreal Expos and Detroit Tigers. (Courtesy Lookouts.)

EDUCATED ARM. Joe Bruno, like Lou Gehrig a Columbia University graduate, was unhittable in 1988, going 7-3 with a 1.21 ERA out of the Lookouts bullpen. He nailed down wins in the regular-season pennant clincher and the final postseason game with hitless relief work. (Courtesy Lookouts.)

Below left: FLEET-FOOTED FAVORITE. Outfielder Bernie Walker was a crowd favorite as a regular in 1988–1989, stealing 46 bases. (Courtesy Lookouts.)

Above right: OLIVER KEY 1988 ADDITION. Catcher Joe Oliver, who failed to hit a triple during the 1988 regular season, looks surprised after hitting a three-base-hit in the Southern League playoffs. He would go on to be the starting catcher for the 1990 World Champion Reds. (Courtesy Lookouts.)

PENNANT PRODUCERS. First baseman Hedi Vargas (left, with manager Tom Runnells) was a key pickup early in the 1988 championship season. Helping earn the first pennant of his 16-year minor-league career, Vargas hit .291 and drove in 61 runs in 82 games. (Courtesy Lookouts.)

ARMS AT REST. The 1988 championship team had more than its share of superb pitching, including, from left to right, Chris Hammond (16-5), Joe Lazor (11-7), and Timber Mead (9-10). At far right is outfielder Chris Jones. (Courtesy Lookouts.)

STRIKEOUT RECORD-SETTER. Big Jim Jefferson brought heat from the bullpen during the 1988 season. He set a Southern League record by striking out eight consecutive Charlotte hitters the first week of the season. (Courtesy Lookouts.)

GOLDEN BROWN. The Brown family made its mark on Chattanooga. Pitcher Keith Brown was on a record pace during the first half of the 1988 pennant run, going 9-1 in 10 starts before his promotion at the halfway point. Brother Ray Brown was second in the league in hitting (.327) in 1996. (Courtesy Lookouts.)

PENNANT FEVER? Lookouts manager Tom Runnells tries to subdue an enraged Luis Reyna during a major brawl that took place in the deciding game of the 1988 Southern League playoffs. Greenville reliever Maximo del Rosario hit Chattanooga hitter Brian Lee Finley after Finley stole a base in the fourth inning with Chattanooga ahead by seven runs. Among the peacemakers are Keith Lockhart (5), Chris Hammond (11, partially behind umpire), and Scott Scudder (right of umpire). (Courtesy Lookouts.)

WHAT A RELIEF IT IS! The pressure's off. The Chattanooga Lookouts celebrate after clinching the 1988 Southern League championship—the only league title in three decades after pro baseball returned to the city in 1976. Celebrants include coach Rich Bombard (being hugged by outfielder Chris Jones) and (capless) first baseman Hedi Vargas. (Courtesy Lookouts.)

TRACY'S TENURE. Manager Jim Tracy failed to make the playoffs during his three-year tenure at the Chattanooga helm (1989–1991) and was fired by the Reds. He would land on his feet, serving as a longtime major-league coach before managing the Los Angeles Dodgers. (Courtesy Lookouts.)

FRONT-OFFICE BOUND. Before taking charge of player development for the Reds and then the Orioles, Darrell "Doc" Rodgers was a solid right-handed pitcher. Rodgers had a 3.27 ERA for a below-average Lookouts team in 1989, among the 10 best in the Southern League, but he returned to Class A the following season. (Courtesy Lookouts.)

HOFFMAN HINTS AT FUTURE. Right-hander Trevor Hoffman was not a member of the Lookouts for very long, but his future major-league greatness was clearly hinted. He was 1-0 with eight saves in a late 1991 debut, and was 3-0 in six games as a starter the following year as the Reds needed him to work additional innings. Hoffman, who is the all-time saves leader in the majors, has never started a big-league game. (Alan Vandergriff photograph.)

FERGIE RETURNS—30 YEARS LATER. After pitching for the Chattanooga Lookouts in 1963, Ferguson Jenkins went on to have a Hall of Fame career. He would return over 30 years later as a roving pitching instructor for the Cincinnati Reds. (Alan Vandergriff photograph.)

TROUBLED TIMES . . . AND A TITLE

OUT WITH THE OLD. The renovation of Engel Stadium meant an off-season mess of bricks, wood, concrete, and metal. (Courtesy Lookouts.)

CALLED ON ACCOUNT OF . . . A SMALL DRAINAGE PROBLEM. Lookouts broadcaster Larry Ward wades to work following an all-too-typical flood in Engel Stadium. Through the doorway, it can be seen that the entire parking lot was underwater. An entire home stand was washed out in 1987 despite clear skies each night. (Courtesy Lookouts.)

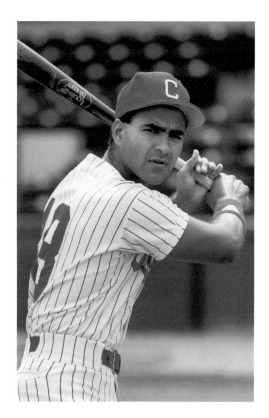

GATHERER OF BAT TITLES. Although small for a first baseman, Adam Casillas could hit. He won three minor-league batting championships in his career, including in 1990 with a .336 mark for the Lookouts. (Courtesy Lookouts.)

LANE LEAVES TOO SOON. Big third baseman Brian Lane, the son of NFL Hall of Famer Harland Lane, overcame a major knee injury and a missed 1991 season to enjoy the year 1993, in which he hit 29 doubles and drove in 57 runs. However, he suddenly retired to go into business in his native Texas. (Alan Vandergriff photograph.)

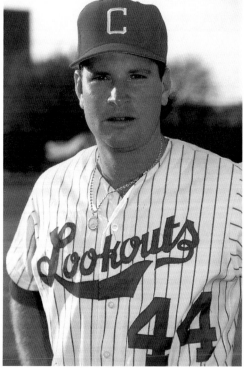

TROUBLED TIMES . . . AND A TITLE

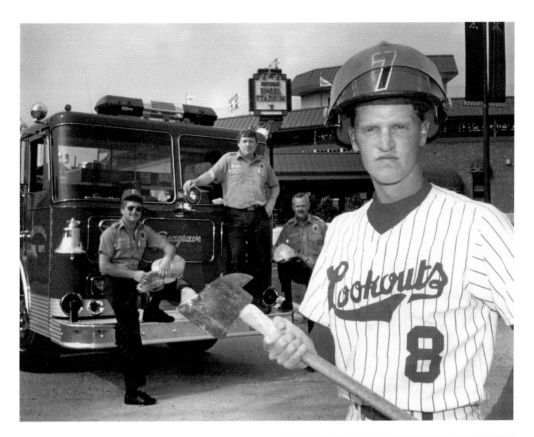

CHATTANOOGA'S FAVORITE FIREMAN.
Members of the Chattanooga Fire
Department helped honor Lookouts reliever
Steve Foster during his stint as the Lookouts'
"fireman." Foster saved 30 games in 1990–
1991, earning a promotion in 1991 with a
1.17 ERA in 17 early-season appearances.
(Courtesy Lookouts.)

A STRIKING POSE. Outfielder Scott Pose not
only got his jersey dirty with great regularity
during the 1992 season, he would lead the
Southern League with 180 hits and a .342
average—and he also wore the same sweaty,
grimy cap for the entire season for good luck.
(Alan Vandergriff photograph.)

GREENE'S DAYS. The close-at-hand right-field wall was ideally suited for the stroke of third baseman Willie Greene in 1992. In just 96 games, he had 19 doubles, 14 home runs, and 66 RBIs while playing the best third base in the league. He was promoted directly to the Reds. (Alan Vandergriff photograph.)

A THREAT TO GO. Infielder Brian Koelling was the Lookouts' biggest stolen base threat of the 1990s, swiping 109 between 1993 and 1997 with a high of 34. He retired following a 1997 season in which he hit .284 and stole 18. (Alan Vandergriff photograph.)

SAVES GALORE. Of all the Lookouts who enjoyed success during the 90-win season of 1992, none enjoyed it more than closer Jerry Spradlin. The 6-foot-7 right-hander set a Southern League record with 34, finishing with a 1.38 ERA in 59 appearances. (Alan Vandergriff photograph.)

GOLDEN SMILE. Reggie Sanders shed the gold tooth before he reached the majors, but otherwise he was golden as a Reds prospect in 1991 with the Lookouts. He hit .315 in 86 games, his season interrupted by a broken hand suffered when hit by a pitch. (Courtesy Lookouts.)

PRODIGIOUS POWER. Tim Costo, a former No. 1 pick of the Cleveland Indians who was traded for former Lookouts first baseman Reggie Jefferson, cut the distant left-field wall down to size in 1992, finishing with 28 home runs—the third-best total ever for a Chattanooga hitter in a single season. He remained a local resident following the end of his career. (Alan Vandergriff photograph.)

SURE-HANDED. Shortstop Freddie Benavides moved quickly from his stint with the Lookouts in 1989–1990 to a big-league career with the Reds, Rockies, and Expos. He returned to the Reds and was a minor-league infield instructor in 2005. (Courtesy Lookouts.)

HARD-HITTING COLVARD. Outfilder Benny Colvard was one of the rare right-handed hitters who was not cowed by the distant fences of Engel Stadium. He hit 44 home runs in three seasons, twice leading the club. He also lead the Southern League in triples in 1991. (Alan Vandergriff photograph.)

RELIABLE RUMFIELD. Willing to do anything, including catch, Toby Rumfield was most often found at first base during his three full seasons in Chattanooga (1995–1997). The Carolina League home run king (hitting 29 in 1994 at Winston-Salem), he was overmatched by Engel Stadium's dimensions, hitting only 22 homers over those three seasons. (Alan Vandergriff photograph.)

BASEBALL IN CHATTANOOGA

JORDAN RULES SOUTHERN LEAGUE. A fluke of the schedule made Michael Jordan's memorable but unproductive 1994 season in the Southern League something Chattanooga fans could share. Jordan's Birmingham Barons played nine games in Chattanooga and overflow crowds showed up for each one—even those games Jordan sat out while enjoying an occasional day off. (Alan Vandergriff photograph.)

LADELL IDEAL FOR ENGEL Center fielder Cleveland Ladell was considered the best defensive player in his position that the Lookouts had seen in years. Overcoming a serious speech impediment, Ladell's best year was 1995, when he hit .292 with 28 stolen bases and 151 hits. (Alan Vandergriff photograph.)

SIDE-ARMER SULLIVAN. Scott Sullivan had a huge 1994 season for the Lookouts, finishing with 11 wins and 7 saves while striking out 111 in 121 innings. It was no surprise that he was still getting hitters out a decade later, spending much of that time as the Reds' top set-up man. (Alan Vandergriff photograph.)

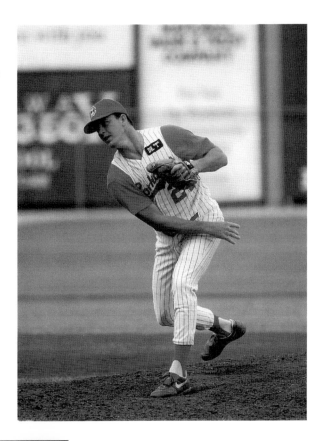

ONE RELIABLE VETERAN. Darron Cox was a mid-season all-star catcher twice for the Lookouts, and he continued his playing career for nearly a decade after last wearing Chattanooga pinstripes. (Alan Vandergriff photograph.)

MIGHTY MOTTOLA. Outfielder Chad Mottola looked and played like a can't-miss prospect after the Reds' No. 1 pick (1992) and has logged big-league time with four different franchises. His best showing in Chattanooga was 1997, when he hit .367 but did not play enough to qualify for the batting title. (Alan Vandergriff photograph.)

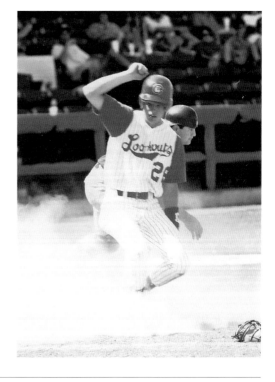

ANOTHER TOP PICK PERFORMS. Outfielder Pat Watkins, who was the Reds' top pick in 1993, logged time over three seasons for the Lookouts before moving on. However, his final go-round with the club saw him hit .350 in 1997. (Alan Vandergriff photograph.)

FERRY TALE, ONE OF TRIUMPH. Pitcher Mike Ferry won 31 games over three seasons for the Lookouts, including a league-leading 13 in 1993. (Alan Vandergriff photograph.)

LOCAL HERO. Continuing a tradition that goes back to the franchise's early days, area product Duff Brumley got a chance to extend his career pitching close to his hometown. Brumley, a Cleveland, Tennessee, native, went 5-1 with a 1.68 ERA in 1995. Over the years, local products like Buck Varner in the 1950s, Robert Long in the 1980s, and Damon Callahan in the 1990s had a chance to play in front of the home folks. (Alan Vandergriff photograph.)

No One Smoother. Shortstop Calvin "Pokey" Reese was not yet 20 years old when first playing for the Lookouts, but the smooth-fielding shortstop brought a rare excitement to the position en route to enjoying a nine-year major-league career. Reese would make the final play for the Boston Red Sox in their historic championship of 2004. (Alan Vandergriff photograph.)

A SHINING CITY ON HAWK HILL

Frank Burke and baseball were meant for each other.

Born into a family of achievers, Burke grew up in Rye, New York, the son of one of America's most powerful media figures, Capital Cities CEO Daniel Burke. During Frank's formative years, his father oversaw the purchase of the American Broadcasting Company (ABC) for a mere $3.5 billion. As Frank joined brothers Steve and Bill as graduates of Harvard, it was merely a matter of what corner of the business world he would make his own.

Steve made a name for himself in the Disney family, appointed as head of troubled EuroDisney to try to turn that multi-billion-dollar white elephant around after overseeing the company's chain of retail stores. Later he would rise to the presidency of cable giant Comcast USA. Bill became a key player in Ted Turner's empire, at times running WTBS (later TBS) and Turner Classic Movies. And his uncle Jim served as chairman of Johnson and Johnson.

When his father became part of a group who bought the Portland, Maine, Sea Dogs, Frank's future began to take shape. Frank, who was running a pair of radio stations, joined his father in checking out other available baseball franchises and came upon the Chattanooga Lookouts.

Frank Burke was all of 34 years old.

When Burke first arrived in Chattanooga following the sale, the newly named managing partner of the ownership group thought he had a historic but manageable ballpark. The truth would become evident soon enough.

"We sorely misjudged the amount of time and effort needed to maintain the stadium," Burke said recently. "We lost well over $100,000 every year. That was largely maintenance, but if the crowd was bigger than a certain size, there was no way we could serve them fast enough. Engel Stadium was a problem, but it is also the best place in the world to watch a baseball game."

Burke did business that way for five seasons, with the upkeep of the stadium becoming a bigger and bigger drain on the bottom line. But the Reds were going through a boom period in their minors, and the Lookouts made the playoffs three of those five years. Burke's favorite promotion was a pair of camels, Larry and Lumpy, who spent each game in a pen in center field. His favorite on-field memories included the occasional home run to left that cleared the new scoreboard (less imposing that the old) and landed on the roof of the BP station pumps across Third Street and the brilliance of center fielder Cleveland Ladell.

Burke began planning for the future—either in or out of Chattanooga. He began sizing up possible stadium sites even while considering the reality that the Burke family group might have to sell out and cut its losses. Fortunately there happened to be a piece of property—no more

than a football field gone to seed, really—that happened to be the best piece of real estate in the entire city. It was called Hawk Hill and the Burkes wanted it.

Unknown to the city fathers, the Burkes had stepped off the hilltop and knew it was physically doable. A remarkable financial plan led to the plan's acceptance. A plan to sell 1,800 season tickets in three months was the final hurdle but one fans met. In less than 48 hours, the Lookouts had every skybox sold and went on to meet the goal nearly a week before the deadline.

Groundbreaking occurred in May, and the parent Cincinnati Reds, the Baltimore Orioles, and former president George Bush and his wife, Barbara, helped dedicate the shiny new park on April 1, 2000.

On the field, despite totally different dimensions, the new yard proved to be equally friendly to potential batting champions. Ben Broussard (.320 in 2001) and Bobby Darula (.325 in 2002) gave the franchise four hitting titles in a five-year span. Pitchers liked it, too; Lance Davis has a league-best 2.18 ERA in 2000.

Some old-time fans refused to climb the hill, figuratively or literally, but their place was taken by entire families. More pre-school-age kids were attending games on one Saturday night that Burke saw for an entire home stand at Engel Stadium.

"[BellSouth] is more family oriented," said former manager Phil Wellman, who was the Lookouts' skipper their final year at Engel Stadium, then returned to take the 2001 team to the playoffs. "It's a completely different aura, but it's still a great place to watch a game. When you're down on that field, you have more of a feeling of being on a stage, that this is more like a theater. You see tons of kids—and in our game, that's very important."

"BellSouth Park cost $10.2 million to build and we borrowed roughly half that money. The debt was paid off in 2005 and now all cash generated by the Lookouts goes to repaying the equity," Burke said. "The Lookouts are safe in Chattanooga for many years to come thanks to my father's big idea."

BURKE "SUSPENDED" ON VINTAGE DAY. Lookouts owner Frank Burke (dapper in hat and suspenders) and first baseman Jamie Dismuke (capless) were among those getting in the spirit of a Turn Back the Clock Day during the 1997 season. (Courtesy Lookouts.)

TRAINS KEEP A-ROLLING. As seen Media Day, 1999, from the concrete right-field wall to the busy rail yard beyond it, not that much changed around Engel Stadium in its 70 years as home of the Chattanooga Lookouts from its opening in 1930 to this, its final season hosting the team. (Courtesy Lookouts.)

No-Hit Aces. The only no-hitters thrown by Chattanooga pitchers since baseball returned in 1976 belong to right-handers Travis Buckley (left) and John Roper. Buckley, a free agent acquisition, pitched only eight games for the Lookouts in 1996, but one of them was a nine-inning no-hitter against Huntsville on June 1. Roper, who was named his league's top pitching prospect in each of his first three seasons, had his no-hitter against Birmingham on August 28, 1992. (Alan Vandergriff photographs.)

First Pitch. Hall of Famer and former Lookout (1957–1958) Harmon Killebrew was at Engel Stadium for a day in his honor in 1990. Killebrew is one of only living Hall of Famers who played in Chattanooga; the other is Ferguson Jenkins. (Courtesy Lookouts.)

MAKING THE MOVE. Without a lot of fanfare, Frank Burke moved only two things from Engel Stadium to BellSouth Park: the unique, eight-foot-high Coke bottles that stood on the center-field wall behind the slope. Made from World War II scrap metal, the bottles have been frequently stolen and/or damaged, but they always made it back to the ballpark. (Courtesy Lookouts.)

A SHINING CITY ON HAWK HILL

WALK A MILE FOR A LOOKOUT. Either you get it or you don't: That was Lookouts owner Frank Burke's philosophy about his camel mascots in the final two years at Engel Stadium. Here, Lumpy (or perhaps Larry) meets fans on the concourse. Burke admitted that he first wanted an elephant. (Courtesy Lookouts.)

THE BUSIEST LOOKOUT. Right-hander Scott MacRae was busier than any other Lookouts pitcher in the first 17 years the Cincinnati Reds supplied players to the club. A Marietta, Georgia, native, MacRae pitched in 167 Chattanooga games with a 28-14 record from 1998 to 2004. (Courtesy Lookouts.)

LaRue Finds Magic. A catcher winning batting titles is rare, but Jason LaRue came within a point of the Lookouts' modern hitting mark with a Southern League–best .365 in 1998. He has been the Cincinnati Reds' starting catcher since 2001. (Alan Vandergriff photograph.)

A SHINING CITY ON HAWK HILL

DYNAMIC DISMUKE. Jamie Dismuke twice hit 20 home runs in a season as the Lookouts' first baseman, and then he returned to his adopted hometown as the team hitting coach in 2002, holding that position through the just-completed 2005 season. (Alan Vandergriff photograph.)

SHUNS SPOTLIGHT. Never wanting the spotlight, Ron Oester had never managed before but accepted the interim job in Chattanooga midway through the 1992 season. He took the team to 90 wins and to within one game of the championship. (Alan Vandergriff photograph.)

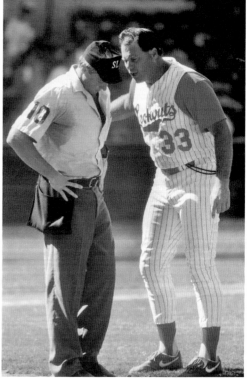

KELLY'S HEROES. Longtime minor-league manager Pat Kelly (right) took the Lookouts to the playoffs in 1994 by winning his division in the second half after finishing last in the first half. He managed the Richmond Braves, Atlanta's Triple-A club, in 2005. (Alan Vandergriff photograph.)

BERRY GOOD. The Lookouts had two winning seasons in Mark Berry's three years as their skipper (1996–1998), but the former catcher passed on a managerial promotion to serve as the Cincinnati Reds' bullpen catcher. That decision was rewarded in 2004 when newly hired Dave Miley made Berry his bench coach, soon to be moved to third-base coach. (Courtesy Lookouts.)

PUTTING ON A SHOW. Phil Wellman, who managed the Lookouts in their final Engel Stadium season of 1999 and returned in 2001, earned the reputation of being one of the most entertaining skippers to ever argue with an umpire. Often his players had to cover their faces or turn away to keep from laughing out loud. (Courtesy Tim Evearitt.)

MVP Performer. Brady Clark made the Lookouts' final season at Engel Stadium noteworthy by winning the Southern League's MVP award as well as the batting title (.326). The outfielder, now starring for the Milwaukee Brewers, was the team's first league MVP since Ellis Clary in 1952. (Courtesy Lookouts.)

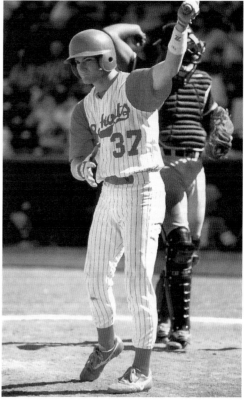

Solid as a Rock. Outfielder Steve Gibralter first played for the Lookouts in 1993 at the age of 20, but after only six major-league games, he fell from favor with the Reds. His career came to an end after the 2001 season in which he rejoined the Lookouts at mid-season and hit 16 homers in a playoff push. Gibralter played in 394 career games in a Chattanooga uniform, hitting 44 homers. (Alan Vandergriff photograph.)

GOOKIE SPANS ERAS. Shortstop Travis "Gookie" Dawkins spanned the old and the new, making his debut with the Lookouts in 1999 at Engel Stadium and, despite two trips to Cincinnati in 1999–2000, playing again for the Lookouts at BellSouth Park through the first half of the 2002 season. (Courtesy Lookouts.)

NOT-SO-GREAT DANE. Catcher Dane Sardinha signed a major-league contract when the Reds made him their second pick in the 1998 draft, but he managed only averages of .206 and .256 in his two seasons behind the plate in Chattanooga. (Alan Vandergriff photograph.)

NIXING LATE RALLIES. James Nix was a major asset as a middle reliever from 1995 to 1997, appearing in 130 games for the Lookouts. His Chattanooga career included a 16-8 record, 13 saves, and a 3.26 ERA, but an injury to his shoulder would bring his career to a screeching halt in 1998. (Alan Vandergriff photograph.)

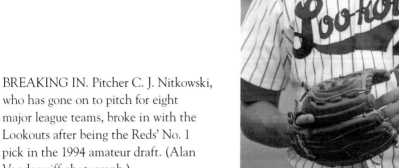

BREAKING IN. Pitcher C. J. Nitkowski, who has gone on to pitch for eight major league teams, broke in with the Lookouts after being the Reds' No. 1 pick in the 1994 amateur draft. (Alan Vandergriff photograph.)

FORMER LOOKOUT
PLAYER RETURNS.
Jayhawk Owens
attended college just
100 miles up the road
from Chattanooga
at Middle Tennessee
State. Owens, like
Red Marion in the
1950s and Sal Rende
in the 1980s, was
a former player for
the Lookouts who
returned to manage
the club. Unlike the
others, he took them
to the playoffs in
2004. (Courtesy
Tim Evearitt.)

LONG-TERM COACH. Hardly an old-timer,
former Reds' minor-league pitcher Mack
Jenkins found success as a pitching coach
and wrote a popular Web site how-to
column in addition to his paying job.
Jenkins worked with several managers as the
Lookouts pitching coach for 6 of his 16 years
in the Reds system. (Courtesy Lookouts.)

CALLING FOR CAL. Cal Ripken was a popular autograph before and during BellSouth Park's dedication game. (Courtesy Lookouts.)

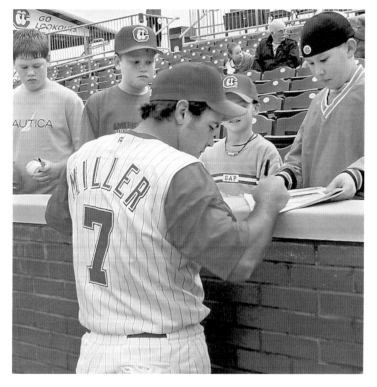

CORKY THE HUMAN TARGET. Catcher Corky Miller, who set a Southern League all-time record when he was hit by a pitch 30 times in the 2000 season, was voted the Most Popular Lookout two years in a row by fans. He was further honored by being the club's first-ever bobble-head doll. (Courtesy Tim Evearitt.)

A SHINING CITY ON HAWK HILL

NEW PARK, SAME RESULTS. The Lookouts had an amazing run of batting champions at Engel Stadium, but the trend continued at new BellSouth Park thanks to first baseman–outfielder Ben Broussard. Later traded to the Indians, Broussard, who broke in with a .407 average in rookie league play, finished the 2001 season with 23 home runs and a .320 average. (Alan Vandergriff photograph.)

BATTING CHAMP DARULA. Bobby Darula, signed by the Reds as a free agent, hit over .300 several times in the low minors but was still a surprise batting champion (.325) for the 2002 Lookouts. With the Reds so overloaded with outfielders, Darula found himself back in Chattanooga for parts of the following two seasons and signed with the Orioles organization in 2005. (Courtesy Tim Evearitt.)

LOOKING THE PART. He looked every bit the role of a third baseman, but Drew Henson was merely a quarterback-in-waiting during his brief stay in Chattanooga. Henson hit only .172 in 16 games for the Lookouts before he was traded back to the Yankees for future Reds standout Wily Mo Pena. Not long after that trade, Henson would quit baseball to quarterback the Dallas Cowboys. (Alan Vandergriff photograph.)

DUNN IN DEMAND. An Adam Dunn autograph was in high demand during his brief stay in Chattanooga, but the slugging outfielder was generous with his time and signature. (Courtesy Tim Evearitt.)

A SHINING CITY ON HAWK HILL

BEST BUDDIES. For a brief glorious time in 2001, the Lookouts had red-hot Cincinnati outfield prospects Adam Dunn (left) and Austin Kearns together at BellSouth Park. Dunn was the first to move up, hitting .343 with 12 homers and 31 RBIs in just 39 games. Kearns, whose bad injury luck began that season, hit .268 in 59 games but returned for rehab stints each of the next two seasons. (Courtesy Tim Evearitt.)

HILLTOP BALL. Cameron Hill (right), one of Chattanooga's historic sites, overlooks Hawk Hill, where Frank Burke built his new stadium in time for the 2000 season. The right-of-way of State Highway 127, one of the city's main thoroughfares, forced Burke to limit the stands on the third-base side. In 2003, he would add additional luxury boxes at the end of the first-base stands. This photo was taken during the dedication exhibition game between the Cincinnati Reds and Baltimore Orioles at the beginning of the 2000 season. (Courtesy Lookouts.)

A REPEAT PERFORMER. Right-hander David Gil was the fastest-rising pitcher in the Reds' 2000 June draft. His career stalled out before reaching the majors but not before he amassed an impressive 19-8 record over parts of four seasons with the Lookouts. (Courtesy Tim Evearitt.)

STRONG-ARMED FOX. His right arm was both his meal ticket and his biggest burden, but Chad Fox was still a rising star while going 4-5 for the Lookouts in 1995. Before the series of operations that undermined his career, he was traded to the Braves the following year for former top outfield prospect Mike Kelly and reached the majors in 1997. (Alan Vandergriff photograph.)

MAKING HIMSELF A PROSPECT.
William Bergolla, an undrafted
free agent, worked his way
into top prospect status with
the Reds. He hit .283 with 36
stolen bases in a productive
2004 season for the Lookouts.
(Courtesy Tim Evearitt.)

THE LATEST PHENOM. Third
baseman Edwin Encarnacion,
considered the Reds' top
position prospect, spent
the entire 2004 season in
Chattanooga and led the
Southern League with 35
doubles. By the end of 2005, he
was established as a Reds' starter.
(Courtesy Tim Evearitt.)

PETE GRAY MOVIE. Several times during the 1980s and 1990s, Engel Stadium was used as a backdrop for period baseball movies. Here, a fake wall adds to the World War II feel of Keith Carradine's portrayal of one-armed outfielder Pete Gray in the 1986 TV movie *A Winner Never Quits*. The band Alabama also filmed a video there for its song "Cheap Seats." (Courtesy author.)

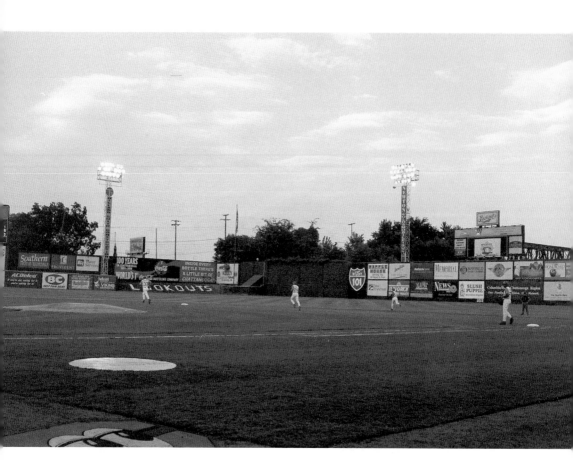

OVERGROWN BALLPARK. Overgrown trees and vines helped create an ideal hitting background at Engel Stadium once an ill-advised sign (left of the 101 shield) was removed. The Lookouts had 15 batting champions and several runners-up in their 70 years at the historic stadium. Owner Frank Burke, who ran the team during its final seasons there, made certain to keep the unique slope holding the LOOKOUTS name in play despite complaints from center fielders over the years. (Courtesy Lookouts.)

GUT CHECK? First baseman-outfielder Lookouts' Turn Back the Clock Day in 1997. Todd "Babe" Trafton added substance to the (Courtesy Lookouts.)

YOUR BOY GUS. Chattanooga sportscaster and music store owner Gus Chamberlain enjoyed the longest tenure of any of Joe Engel's broadcasters, lasting 12 seasons until the team was disbanded in 1965. Chamberlain, who died one year after Joe Engel in 1970, broadcast games on three different stations during his stint and served as a radio sports reporter until his death. (Courtesy Chattanooga Regional History Museum.)

HALL OF FAME VOICES

Like most minor-league clubs, the Lookouts have had an array of play-by-play broadcasters over their long history. But three names—voices—stand out as being truly special.

Arch McDonald, Joe Engel's first play-by-play man, was "traded" to the Washington Senators by the wheeler-dealer club president. A Chattanooga native who graduated from the prestigious McCallie School there, McDonald began as public address announcer at the new Engel Stadium and was actually recommended by Engel to boss Clark Griffith when the Senators' owner sought to put some of his games on the air after winning the American League pennant in 1932.

McDonald had built a solid reputation in a short time. *The Sporting News* invited readers to name their favorite announcer and a suspiciously heavy turnout tabbed McDonald with that honor, despite working for a relatively small station in Chattanooga that was hardly national in its range. But McDonald proved to be game for Engel's little stunts, as he once broadcast the Opening Day parade while riding a camel.

McDonald would go on to become the first play-by-play voice of the Giants and Yankees, doing only home games as one team was always on the road, and called games for a total of 23 seasons. He would also enjoy a tenure broadcasting the Washington Redskins. He died suddenly at age 59, traveling from a college football broadcast to a Redskins game.

McDonald explained his philosophy in a 1942 interview in *The Sporting News*:

> In a big field, you have a crowd of 50,000 fans. Of these, 2,000 sit in the box seats, the upper crust. The other 48,000 are the dollar guys—the fellows you try to reach. Give them the game as you know it. Be as brief as possible. Above all, don't be a know-it-all. Let the fans think you are telling the story just as they would tell it. Use penny words and let the dollar words take care of themselves.

McDonald was inducted into the broadcaster's wing of the Baseball Hall of Fame and Museum in 1999.

While Tom Nobels took over the microphone during the 1940s, it's not going too far out on a limb to say that Gus Chamberlain was Engel's favorite announcer, broadcasting games for 12 seasons until the demise of the franchise in 1965. Chamberlain was also the city's foremost sports reporter, his career on television keeping him busy in the absence of baseball until his death in 1970 at age 52.

Chamberlain, a Baylor graduate, was also a huge fan of bandleader Gus Lombardo and owned a record store locally for many years. His colleague in both the Engel Stadium press box and in radio, Luther Masingill, said when Chamberlain died, "He was undoubtedly the most colorful

local radio man I've ever known—mostly because of his enthusiasm and his famous temper."

There was no one clear choice to assume that role when the Lookouts returned in 1976, going through an assortment of short-timers until Larry Ward came to stay in 1989. The most notable short-term announcer was Jim Kelch, who moved to Louisville after one year but remained with that Triple-A franchise for the following 18 years.

Ward actually debuted as the Lookouts' voice in 1987 before a brief side trip to do college football and basketball. Once he returned a year later, he came to stay, adding duties as a college basketball announcer as well as anchoring then-owner Rick Holtzman's ahead-of-its-time all-sports radio station, WJOC. Before the 2005 year, he was inducted into the Chattanooga Sports Hall of Fame.

Ward grew up in the Northwest on a 7,000-acre ranch, limiting his exposure as a young ballplayer. But the curve ball and a taste of broadcasting at the high school level set him on his course. He remains the "Voice of the Lookouts" today. Ward said:

> When I came back to the Lookouts in 1989, replacing a then-fired announcer who had been just hired, I brought my family under duress. But they would eventually become just as much in love with Chattanooga as I after a couple of seasons. The first three years were tough with the Reds not having much to offer the locals. In fact manager Jim Tracy would finish his final season using pitchers as position players because the organization was shorthanded. Tracy became a fast friend. Ask one question, hand him the microphone and a few minutes later the pre-game interview was complete. Tracy would be fired in a couple of years because of disagreements with management. I wonder what happened to him?

Ward, who also handled the club's travel arrangements, admitted a special relationship existed between he and the managers who served during his years. There were Dave Miley and first-time skipper Ron Oester in 1992, Oester filling in as Miley was promoted and helped the Lookouts to 90 wins and within one win of a championship. Miley would return to take the 1995 team to the playoffs and eventually got his chance to manage the Reds.

"Between the Miley appearances was Pat Kelly, who was nearly fired during his second season because prima donnas that were playing decided they should run the team and not him," Ward recalled. "The team made the playoffs yet almost to a man the players were packed and upset they had to stick around. The Lookouts were dumped in three games by Huntsville and you could tell the players had no remorse over the deal."

Following Miley in 1995 were young energetic skippers Mark Berry, Phillip Wellman, and Jayhawk Owens, as well as Mike Rojas, who had the inaugural 2000 season at BellSouth Park. Berry and Owens would earn playoff spots.

Ward commented:

> Each man brought a special talent to Lookouts baseball each year. I found out early in my career that the manager of a ball club has to have trust in his announcer. In my case even more as my relationship goes beyond broadcasting the games. You become a sounding board and you have to have the manager's confidence that what he tells you goes no further. Not even to your wife.
>
> On the field, I had a chance to call no-hitters from John Roper and Travis Buckley. Frank Kremblas played every position in one game, as would Steve Eddie and Greg Lonigro later. I was able to call batting championships by Adam Casillas, Scott Pose,

Jason LaRue, Brady Clark, Ben Broussard and Bobby Darula. Others that kept us busy with a "goodbye baseball" home run call included Tim Costo, Adam Dunn, Austin Kearns and Jamie Dismuke.

"I wonder after working with three different owners, four general managers and three league presidents how long this ride will last," Ward said. "This is a labor of love, all of it: long bus rides, extra-inning games, home runs, shutouts, wins and losses. It is also my passion and I hope the ride will continue as long as possible."

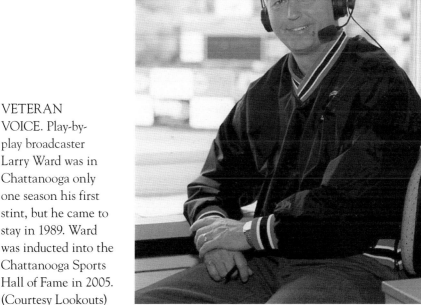

VETERAN VOICE. Play-by-play broadcaster Larry Ward was in Chattanooga only one season his first stint, but he came to stay in 1989. Ward was inducted into the Chattanooga Sports Hall of Fame in 2005. (Courtesy Lookouts)

CHATTANOOGA'S OWN PRODUCTS. Brothers Jimmy (left) and Doc Johnston (right), shown here talking to ball player and entertainer Al Schact, were two of the earliest and best products of Chattanooga's amateur baseball leagues. Jimmy Johnston went on to play in the big leagues from 1911 to 1926 and managed the Lookouts for then-owner Sammy Strang Nicklin from 1927 to 1929 (when Clark Griffith and Joe Engel took over). Doc (given the name Wheeler) also enjoyed a major league career from 1909 to 1922. Both remained Chattanoogans for life. Doc passed away in 1961 and Jimmy in 1967. (Courtesy Joe Engel collection, the Baseball Hall of Fame Museum, Cooperstown, New York.)

10

AMATEUR BASEBALL

The here-today, gone-tomorrow existence of Chattanooga's professional team in the early years of the 20th century gave birth to a thriving amateur baseball program. Rising to a competitive level in a short time, amateur baseball endured in the city long after the Lookouts had arrived to stay.

The City League was formed in 1907 to help fill the baseball void, and it spawned several future professional players, including major-leaguers (and brothers) Jimmy and Doc Johnston. The City League's success was evidence enough for local businessmen O. B. Andrews and Z. C. Patten that Chattanooga would support professional baseball given more of a chance.

By 1909, the Lookouts were a reality. Within the next two years, Andrews had built a stadium for his team alongside the city's massive rail yard. That location would prove to be ideal for Joe Engel's new ballpark when his boss, Clark Griffith, bought the team from new owner Sammy Nicklin. Following the 1999 season, when the Lookouts left Engel Stadium for good for new digs on Hawk Hill, the site alongside the still-thriving rail yard was again home solely to amateur baseball.

The University of Chattanooga (as the University of Tennessee at Chattanooga was then called as a private school) organized its first true baseball team on a shoestring budget in 1967. Coached by Don Shaver, the Moccasins surprised many by having a perfect 8-0 record in that first season and celebrated the unbeaten year as if it was an NCAA championship. That university team would include on its small roster Pat Woosley, who would go on to be one of the state of Tennessee's most successful high school coaches, with championships earned both in Chattanooga and Nashville.

Woosley and Bill Redd are the only baseball players honored in UTC's sports Hall of Fame.

Baseball at UT-Chattanooga came to an end with a doubleheader sweep of Western Carolina in April 1982. It was a memorable day in its own right as the Catamounts entered the day in the first place in the Southern Conference. UTC freshman pitcher Chad Jones, of Ringgold, recorded a win in the first game at Engel Stadium and entered late in the second to get another victory.

Western Carolina was coached by Jack Leggett, who was the baseball coach at Clemson University in 2005.

The final Mocs baseball team was told by UTC athletic director Harold Wilkes on April 1, 1982, that the program was being dropped.

One baseball player was quoted in the *Chattanooga News-Free Press* as saying, "I thought at first it was some kind of April Fools joke." Wilkes told the paper that he was not blaming the NCAA, but if the school had remained in 1A, dropping baseball would not have been an option. "It's a very popular sport, very popular, and I knew the decision would probably be an unpopular one," Wilkes told *Free Press* writer Ron Bush.

Wilkes gave different reasons for dropping baseball. The list of reasons included: the school not owning a baseball facility, classes ending in April, players missing classes during the spring semester, and lack of funding. "The field was one thing, money was one thing, classes and classes missed are one thing and the early out is another thing," Wilkes said. "When you combine all of them you make a decision."

The players scattered. Head coach Bob Brotherton said the last team, which broke the school record for wins, had 30 players, with 22 freshman and sophomores. Brotherton said the team had "turned the corner" and good things were ahead for the program. Brotherton hardly broke stride, building a program and stadium for the city's fast-growing community college, Chattanooga State, while his assistant, Marvin "Stump" Martin went on to become a local sportswriter before crossing over into cable television and radio programming. As a result, the controversial death of the program was constantly coming up.

"It was a common sense decision the way that Coach Wilkes saw it," Martin said. "Something had to be dropped. Jim Morgan, the assistant athletic director, was the wrestling coach. His sport wasn't eliminated. And Neil Magnussen, the assistant to the athletic director, and coached soccer. His sport was not dropped either."

Ironically blueprints had been drawn and land cleared for a field on school grounds. Instead it was given to the band as a practice field, the diamond-shaped light towers a reminder of what could have been.

"The field was there and the lights were set for baseball," Martin said. "But, other university officials had a different idea of how they wanted to see the field used. The director of intramurals wanted the field for his use, and the school's marching band had to have a place to practice. But, there were blueprints made of the baseball field."

UTC had played most of its home games at Engel Stadium, even during the years when it otherwise sat unused. Also using it, and doing a lot of work to make it fan-friendly, was the city's large Christian college, Tennessee Temple. The teams played in UTC's final season, and the assistant Temple head coach John Zeller was future major league general manager Kevin Malone. The dynamic Malone would go on, first to become the assistant general manager of the Baltimore Orioles, then general manager of the Montreal Expos, and the Los Angeles Dodgers.

Brotherton later coached baseball for 11 years at Chattanooga State. Many of his players went on to play baseball at four-year schools and some professionally. One of those was right-handed pitcher Kerry Lacy, from North Sand Mountain, Alabama. Lacy was drafted out of Chattanooga State by the Texas Rangers. He later became a closer for the Boston Red Sox and also pitched relief for the Chicago Cubs.

"He was a character, but a very talented athlete," Brotherton said. "He could play any sport and was offered a scholarship to punt for Alabama."

Rod Bolton also attended Chattanooga State and played Major-League Baseball with the Chicago White Sox. The Ooltewah graduate played for Derek Lance, who first came to Chattanooga as an assistant at UTC for Brotherton.

"Bolton had a nasty slider," Brotherton said. "And he was such a great guy. Everybody loved Rod and he was an ambassador for Chattanooga baseball wherever he played."

Chattanooga State's and Tennessee Temple's programs continue in the present days. Former Notre Dame High School shortstop Greg Dennis, whose brother Mark was an assistant general manager to the Lookouts under Bill Lee, is now the head coach at Chattanooga State.

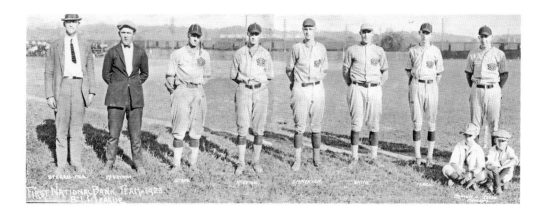

EARLY ANDREWS FIELD OCCUPANTS. The First National Bank team of 1923 is pictured in a rare image of Andrews Field, which stood on the present site of Engel Stadium but faced the opposite direction. Andrews Field, which was sold by Sammy Strang Nicklin to Senators owner Clark Griffith, was torn down to make way for Engel Stadium in 1930. Nicklin, president of the Lookouts in the 1920s, had purchased Andrews Field from O. B. Andrews and Z. C. Patten in 1922. The First National Bank team members include, from left to right, (above) manager Stegall, assistant McBryant, (Fredd) Stapp, McVeigh, Emmerson, Smith, Clark, and Wheelock; (below) Dobbs, Mason, Wassman, Donovan, Milliken, and scorekeeper Keating. Mascots in the top image on the far right, seated are Morton and Ellis. (Courtesy author.)

LOCAL PRODUCT. Rod Bolton, a Chattanooga-area prep star, played at Chattanooga State Community College for Coach Bobby Brotherton before going on to the University of Kentucky and an eventual big-league career. He was drafted by the Chicago White Sox in the 13th round and eventually got a chance to pitch in his hometown in 1991 for the Birmingham Barons before reaching the big leagues. (Courtesy author.)